Echoing Images

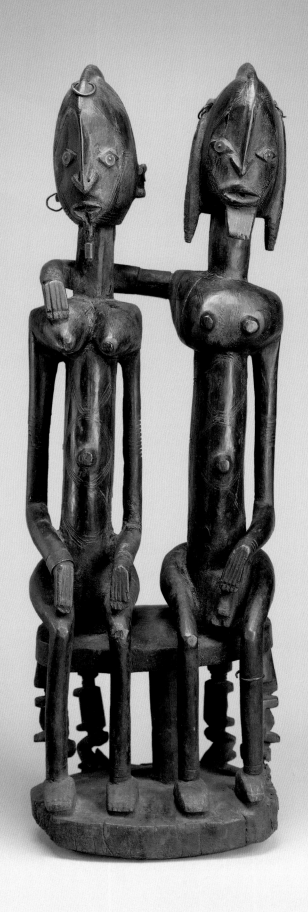

Echoing Images

COUPLES IN AFRICAN SCULPTURE

by Alisa LaGamma

THE METROPOLITAN MUSEUM OF ART, NEW YORK

YALE UNIVERSITY PRESS, NEW HAVEN AND LONDON

This volume is published in conjunction with the exhibition "Echoing Images: Couples in African Sculpture" held at The Metropolitan Museum of Art, New York, February 10–September 5, 2004.

This publication has been made possible through the generous support of Laura G. and James J. Ross, the Gulton Foundation, Inc., and the MCS Endowment Fund.

Published by The Metropolitan Museum of Art, New York

John P. O'Neill, *Editor in Chief*
Ellen Shultz, *Editor*
Jo Ellen Ackerman, *Designer*
Peter Antony, *Production Manager*

Photographs by Karin G. Willis, The Photograph Studio, The Metropolitan Museum of Art, except for the following: plate 10, courtesy of the High Museum of Art, Atlanta; plate 12, courtesy of the Brooklyn Museum of Art; and plate 22, courtesy of the American Museum of Natural History, New York, Photo by Lynton Gardiner.

Library of Congress Cataloging-in-Publication Data

LaGamma, Alisa.
 Echoing images : Couples in African sculpture / by Alisa LaGamma.
 p. cm.
 Catalog of an exhibition at the Metropolitan Museum of Art, New York, Feb. 10–Sept. 5, 2004.
 Includes bibliographical references.
 ISBN 1-58839-108-6 (pbk.)—ISBN 0-300-10358-1 (Yale University Press)
 1. Couples in art—Exhibitions. 2. Sculpture, African—Exhibitions. I. Metropolitan Museum of Art (New York, N.Y.) II. Title.

 NB1935.5.L34 2004
 730'.89'96073--dc22 2003026152

COVER
Male and Female Figural Pair. Mangbetu peoples, Democratic Republic of the Congo. See plate 21.

FRONTISPIECE
Primordial Couple. Dogon peoples, Mali, 16th–19th century. Wood and metal, H. 28¾ in. (73 cm). The Metropolitan Museum of Art, New York. Gift of Lester Wunderman, 1977 (1977.394.15)

Printed in Singapore

Contents

Director's Foreword

"Echoing Images" examines a single iconographic subject that has been an enduring concern of sculptors in many of the world's civilizations, especially those from sub-Saharan African cultures: idealized figurative pairs. Created by artists from Mali to Madagascar, the works in this special exhibition constitute explorations of the duality of the human condition and the quintessential desire of individuals to seek out unions with some complementary other in order to fulfill their existence. Masaccio's *Expulsion from the Garden of Eden* in the Brancacci Chapel in Florence ranks among the most searching portrayals of the archetypal couple in Western art. In that searing and timeless visual commentary, Adam and Eve are depicted at the moment when they are forced to become self sufficient, newly united in their shared suffering and responsibilities. The iconic African work that introduces this exhibition is also remarkable for its universally comprehensible commentary: The concise visual vocabulary of the Dogon *Primordial Couple*, one of the most beloved works in The Metropolitan Museum of Art's permanent collection, provides an eloquent statement concerning the unity of man and woman as an elemental social unit. Together with the exceptional works included here, which address comparable subject matter from a range of different cultural perspectives, it attests to the rich diversity of artistic traditions that have flourished in Africa.

With this exhibition, the Metropolitan Museum furthers its ongoing commitment to present outstanding works of African art. Our aim is at once to emphasize the aesthetic power of African sculpture while advancing awareness and understanding of its sources of inspiration and significance. Organized by Alisa LaGamma, Associate Curator in the Department of the Arts of Africa, Oceania, and the Americas, "Echoing Images" builds on previous efforts to interpret and celebrate masterpieces of African creativity at the heart of one of the world's great cultural institutions.

For this undertaking, we have relied on the generous partnership of important donors and lenders in our community. On behalf of the Museum I would like to thank Laura and James Ross, whose contribution enabled us to publish this catalogue. We are also deeply grateful to Drs. Marian and Daniel Malcolm and the MCS Endowment Fund for their invaluable support in the realization of this endeavor. Finally, we extend our appreciation to all the lenders to the exhibition, and, in particular, to William, Ann, and Daniel Ziff.

Philippe de Montebello
Director
The Metropolitan Museum of Art

Acknowledgments

The African works included in this exhibition represent a series of artistic reflections on a fundamental aspect of human experience—essential partnerships and relationships. I would like to acknowledge the collaborative roles of many individuals in this endeavor. In suggesting the theme of the exhibition, James Ross shared his vision with me, and the project has greatly benefited from this encouragement and the exposure to exceptional art along the way, as well as from the friendship that he provided in the process of bringing it to fruition. I also wish to express my heartfelt thanks to Marian and Daniel Malcolm for their unfailing support and their contributions to the success of this effort. Fred and Rita Richman kindly made available to us a work from their collection, a recent gift to the High Museum of Art in Atlanta; we thank them and Michael E. Shapiro, Nancy and Holcombe T. Green, Jr., Director of the High Museum, for that important loan to the exhibition. Esteemed colleagues William Siegmann at the Brooklyn Museum of Art and Enid Schildkrout at the American Museum of Natural History, New York, also generously facilitated loans from their respective institutions. I wish to express my appreciation to all the other lenders who graciously granted me access to the works in their collections: Bernice and Sidney Clyman, Drs. Nicole and John Dintenfass, Carol and Jerome Kenney, Elliot and Amy Lawrence, Brian and Diane Leyden, Robert and Nancy Nooter, Holly and David Ross, Herbert and Lenore Schorr, Daniel Shapiro, Jeffrey B. Soref, Faith-dorian and Martin Wright, and the Ziff family.

The realization of this exhibition would not have been possible without the dedication and sustained efforts of the staff of the Department of the Arts of Africa, Oceania, and the Americas at the Metropolitan Museum, under the leadership of Julie Jones, Curator in Charge, and the invaluable assistance of Hillit Zwick, Emma Ross, Shauna Doyle, and Victoria Southwell.

In addition, the talents of many members of the Museum's staff were enlisted. I am especially grateful to Barbara Bridgers of The Photograph Studio for the opportunity to collaborate with Karin L. Willis, Photographer, whose efforts, together with the much-appreciated work of Ellen Shultz, Editor, and Peter Antony, Chief Production Manager, in the Editorial Department, have immeasurably enhanced this volume. Finally, the publication was overseen throughout by John P. O'Neill, Editor in Chief and General Manager of Publications.

Invaluable support for this project was provided by Chief Registrar Herbert M. Moskowitz and his staff in the Office of the Registrar, coordinated by Lisa Cain, Assistant Registrar. For the extensive preparations of the works on exhibition, I thank Ellen Howe, Conservator; Alexandra Walcott, Assistant Manager for Installation; and Jenna Wainwright, Installer, in the Department of Objects Conservation. Michael Langley, Designer, Emil Micah, Graphic Designer, and Clint Coller and Rich Lichte, Lighting Designers, in the Design Department, were responsible for the handsome presentation of the works.

A. L.

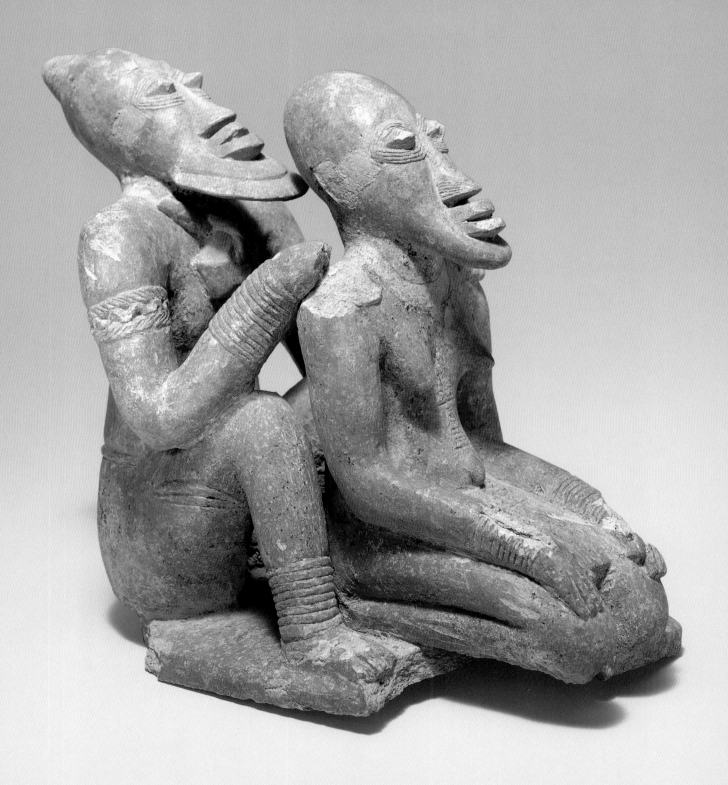

Echoing Images

COUPLES IN AFRICAN SCULPTURE

by Alisa LaGamma

ACROSS THE VASTNESS and complexity of sub-Saharan Africa, and over the centuries, representations of couples have evoked a fundamental desire of the human condition—a yearning of the individual to transcend isolation and connect with an "other." Figurative pairs created by artists from the extreme reaches of the continent, ranging from the Dogon of Mali to the Sakalava of Madagascar, constitute artistic explorations into this realm of duality. That aesthetic quest at once engenders original and distinctive creations and commentaries that touch on a universally accessible theme. While these figures grow out of a mythos present in many cultures around the world, images of idealized figurative pairs often express underlying social and philosophical ideas concerning duality that are culturally specific.

The term "couple" suggests the presence of a bond that joins two elements together. Although Western social conventions have conceived of such pairings as comprising a man and a woman, the term also can be applied to two persons or forces paired together. Both a quintessential human desire to seek out unions with other human beings and the duality of the human condition have been the source of philosophical speculation since antiquity.

Plato in his *Symposium* (1937, pp. 317–18) has Aristophanes discourse on human evolution. The nature of humanity in its original state is described as consisting of three genders that correspond to the sun, earth, and moon: man, woman, and man-woman. Each of these beings is believed to have a double physical

PLATE 1 Seated Couple. Djenne Civilization, Mali, 12th–16th century. Terracotta, H. 10 in. (25.4 cm). Collection Drs. Daniel and Marian Malcolm

nature, with two faces looking in opposite directions and two sets of bodily features. In this account, Zeus subsequently altered humanity's original state by enfeebling it, dividing all three of the sexes into halves so that they retained an innate sense of incompleteness: "So ancient is the desire of one another which is implanted in us, reuniting our original nature, making one of two, and healing the state of man. Each of us when separated, having one side only, like a flat fish, is but the indenture of a man, and he is always looking for his other half." Plato's version of human development attempts to account for two different aspects of human character: the fact that we seek out partnerships that allow us to connect with others and the idea that every one of us has multifaceted internal dimensions to our being.

Comparable theories concerning a fundamental state of human duality have been developed and are reflected in the beliefs and artistic traditions of many societies. Throughout history, and around the globe, we are provided with many illustrations of how the concept of duality is conceived of and expressed. Such notions of duality are widely apparent in ancient Egyptian civilization, where the very emergence of life is attributed to four pairs of creation deities who gave shape to a universe composed of complementary heavenly and earthly halves that, in turn, were subdivided into Upper and Lower lands. A widespread tradition of figurative pairs carved from a single block of stone, or dyads, developed as a form of artistic expression in the New Kingdom beginning in the 4th Dynasty. While royal dyads depict the king in the company of a divinity, private ones represent a man and his wife. Such representations of couples are notable departures in Egyptian art for the intimate nature of the human interactions that are displayed: through gestures of affection, husband and wife hold hands or have their arms around one another. Pairs of identical funerary portraits of a single individual may give expression to another aspect of human duality by distinguishing between the subject's physical and spiritual manifestations or mortal and deified states.

In Greek and Roman mythology, the heavenly twins Castor and Pollux figure prominently as emblematic of a divine pairing. The offspring of Leda and inseparable from one another, Castor is often characterized as the mortal son of Tyndareus, the king of Sparta, and Pollux, as the immortal son of Zeus. When Castor is slain, Pollux gives up his immortality to remain with his brother and the two are ultimately transformed into the constellation Gemini by Zeus. Referred to as Dioscuri, they are represented on early Roman coinage and in art as two youths who are often armed horsemen. The Romans also associated them with another celebrated pair of twins, Romulus and Remus, the legendary founders of Rome. Sons of the war god Mars and Rhea Silvia, they were abandoned to be drowned in the Tiber only to be spectacularly rescued by a she-wolf who raised them until they were discovered by a herdsman. Their identity as Rome's founders is immortalized in images of a she-wolf suckling two infants, the most famous of which is the bronze sculpture in the Museo Capitolino, Rome.

In the ancient Americas, a celebrated pair of heroic twins are the main protagonists of the *Popol Vuh,* the sacred book of the Quiché Maya of highland Guatemala in which the creation of the world is recorded. The Hero Twins, Hunahpa and Xbalanque, strive to overcome the Lords of the Underworld and eventually become the sun and the moon. Scenes illustrating their epic exploits have been identified on Late Classic painted ceramics in the southern Maya lowlands.

Throughout Mesoamerica, concepts of a fundamental creative force that is responsible for initiating, structuring, and maintaining the universe are personified by divine primordial entities of dual gender represented in the imagery of Aztec, Mixteca, Puebla, and Lowland Maya pictorial manuscripts.

Among the many other examples of duality in art and culture, perhaps the most widely known are Yin and Yang, the combination, fusion, and perfect balance of two cosmic forces in Eastern philosophy, and Shiva and Parvati, whose perpetual union is responsible for the universal flux of creation in Hindu traditions. Africa's ethnic and cultural diversity provides a vast landscape in which sculptural pairs take on a variety of forms reflecting deeply significant cultural meaning. Given their prominence as a subject addressed by African artists across the continent, the theme of couples was one of five distinct cross-cultural motifs examined by art historian Herbert Cole in his 1989 exhibition "Icons: Ideals and Power in the Art of Africa" at the Smithsonian Institution's National Museum of African Art.

An African Masterpiece: The Dogon Primordial Couple

One of the most celebrated works by an African master to comment on human duality is a seated couple in The Metropolitan Museum of Art's collection created by a Dogon master in Mali as early as the sixteenth century (see frontispiece). The work's scale and complexity have led scholars to suggest that it may have been created for display at the funerals of influential Dogon men (Ezra 1988, p. 65). The figures' graphic composition constitutes an eloquent statement concerning the distinct yet complementary roles of male and female partners as a unit of life. With understated elegance and an economy of details, the artist distills man and woman in a perfectly integrated and harmonious union. One of the most striking aspects of the representation is its degree of bilateral symmetry: Man and woman appear as reflections of one another with delicate and subtle departures to indicate their distinct identities. The figures' elongated bodies are depicted as a series of parallel vertical lines traversed by horizontals that draw them together.

The most significant of those unifying elements is that of the male figure's proper right arm, which reaches out across the back of the female's neck, the hand resting on her breast. The gesture draws the two together formally and provides a counterpoint to the male's other hand, which indicates his genitalia and thus his role as progenitor. With this very human gesture of affection, the artist highlights the breast as emblematic of the female's identity and as the source of nourishment for new life. The parallelism of the faces, with their arrow-like noses and lozenge eyes and mouths, diverges only at the bases of the chins: The male's rectangular beard is complemented by the female's vertical lip ornament, or labret. There is also formal differentiation in the chest areas between the female's full, rounded breasts and the male's small nipples. The otherwise identical torsos are framed by long, narrow vertical arms that terminate in hands positioned at knee level, where the legs extend to the base as a series of four parallel lines. This symmetry continues on the reverse side: A small child depicted clinging to the female is balanced by a quiver on the back of the male. That concluding pair of corresponding features distinguishes their respective roles as nurturer and provider, which unite to procreate and to sustain life. While this masterpiece of African art is lyrical in its visual clarity and its delicate innuendo, it is as concise as a mathematical equation.

I The Couple in Sudanic Artistic Traditions

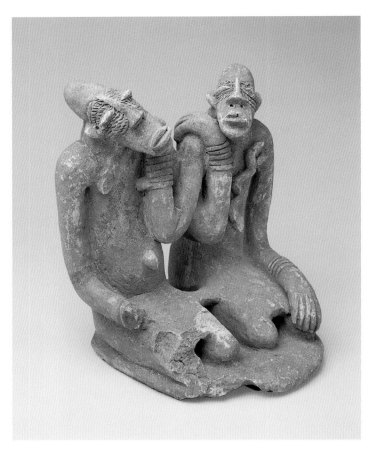

PLATE 2 Seated Couple. Djenne Civilization, Mali, 12th–16th century. Terracotta, H. 11 1/8 in. (28.3 cm). Collection Drs. Daniel and Marian Malcolm

It has been suggested that the emphasis on both the unity and separation of the male and female in African thought is especially intense in Sudanic sculptural traditions (DeMott 1982, p. 31). In surveys that consider the vast and richly diverse artistic heritage of sub-Saharan Africa, art historians have identified regional traditions that encompass vast geographic territories. Classifications such as "Sudanic" suggest an overarching culture and artistic legacy shared by many distinct ethnic groups (Sieber and Rubin 1968, p. 20; Wingert 1962, p. 95). Among those sub-groups included within the area of Sudanic style are the Dogon, Bamana,

Senufo, Lobi, and Baga. In physical terms, the Western Sudan is a landscape of desert, grassland, and wooded savanna that extends from Senegal through Chad. Delimited to the north and south by the Sahara and the Atlantic Coast, at its heart is the great arc of the Niger River. As early as the first millennium B.C., the inhabitants of the Western Sudan were engaged in both farming and ironworking technologies. Over time, they participated in the formation of three important pre-colonial kingdoms — Ghana (from about the eighth to the eleventh century), Mali (from about the thirteenth to the sixteenth century), and Songhai (from about the fifteenth to the seventeenth century) — that prospered through trans-Saharan trade. Commercial networks exchanged salt and brass for gold, ivory, kola nuts, and slaves, and, by the tenth century, facilitated the spread of Islam from North Africa across the Sahara to the Akan forest region in present-day Ghana.

I A. ANCIENT DJENNE

Among the earliest forms of artistic expression in the Western Sudan are depictions of couples in terracotta and cast copper alloy, from Mali's Inland Niger Delta. These works have been related to the ancient urban center of Djenne-Jeno three kilometers southwest of the contemporary city of Djenne. Archaeologists have determined that the site was settled about 250 B.C., and that it was continuously occupied by an ethnically diverse population for over a millennium before its abandonment about A.D. 1500 (McIntosh and McIntosh 1975, p. 51). By A.D. 500, Djenne-Jeno's fine local pottery was being traded upriver and there is evidence that early sculpture was manufactured. Copper and salt brought by Saharan traders were exchanged for the region's abundant fish and agricultural resources (McIntosh and McIntosh 1981, p. 20).

Islam's penetration of the region about A.D. 1000 coincides with the production of figurative terracottas at Djenne-Jeno, which some have proposed may have been a direct response to an assault on indigenous belief systems (Garlake 2002, p. 99). It has been suggested that Djenne-Jeno's decline may be related to the arrival of Islam, and that a new urban settlement purged of traditional religious practices was established at Djenne once the community's leadership converted to the new faith (McIntosh and McIntosh 1981, p. 17).

The corpus of figurative terracottas associated with Djenne-Jeno's civilization is immensely diverse iconographically. In addition to a group of armed foot soldiers and horsemen, there are representations of individual men and women attired simply in girdles, anklets, and bracelets, in attitudes suggestive of prayer or supplication. Some of the subjects addressed are figurative pairs that suggest relationships of intimate companionship. To date, approximately thirty-six terracotta sculptures as well as fragmentary remains of artifacts and reliefs have been found as part of controlled excavations in the vicinity of Djenne-Jeno (Garlake 2002, p. 103), among them a pair of male and female figures discovered positioned next to the foundation of a house at a site northwest of Djenne (McIntosh and McIntosh 1975, p. 53). Excavated from under what appears to have been the floor, the figures, both missing their heads, are shown kneeling with their hands placed on their knees, their bodies covered with raised dots of clay. This dramatic surface treatment is apparent on other related ancient terracottas from the region. It is unclear whether the markings portray an aesthetic practice or lesions resulting from disease. Another pair of kneeling terracotta figures without "lesions" was found on a platform built into the walls near the entrance to a house (Garlake 2002, p. 103).

While it is difficult to arrive at any conclusions based on such a limited contextual record, it is intriguing to consider that in more than one instance representations of couples were interred near the entrances to domestic compounds. Within the larger corpus of known Djenne terracottas, figural pairings are a recurrent theme. In one especially eloquent treatment, illustrated in plate 1, a man and woman are represented in a single sculptural arrangement. The complex nature of that interrelationship draws upon the intersection of parallel postures. The female figure kneels with her hands placed on her knees while the male figure, seated directly behind her, rests his hands on her shoulders. The elongated supple limbs of both figures are rendered with an elegant fluidity. In keeping with the approach shared by other related regional works, the figures' eyes, noses, and lips project prominently from the surface. Their respective identities are subtly articulated by the female's exposed breasts and the male's beard and prominent pectoral ornament. These details and the contrast in facial orientation — while he gazes upward, she looks straight ahead — suggest deliberate distinctions that are seamlessly united.

In addition to representations of male and female figural pairs, ancient Djenne's artists also depicted pairs of figures of the same gender, as in the pair of male figures that kneel side by side, with interlaced arms, seen in plate 2. This is evident in works in brass, such as the miniature in plate 3, which is closely related stylistically to the terracottas: The two virtually identical bearded male figures wear their hair in a distinctive topknot. They are seated side by side, their hands resting on bent knees. A wavy serpentine vertical motif is emblazoned along the length of each of their torsos, terminating in a prominent navel. Even though the surfaces are worn through handling, it is apparent that the figures' features were cast to project prominently in relief. The intimate scale of this work suggests that it served as a personal pendant and may have had amuletic properties.

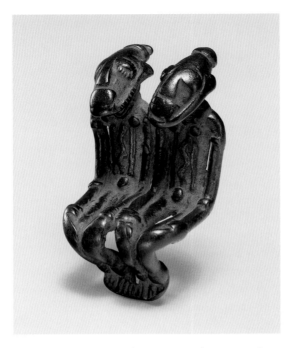

PLATE 3 Pendant: Couple. Djenne Civilization, Mali, 15th century. Brass, H. 2⁹/₁₆ in. (6.5 cm). Collection Jeffrey B. Soref

I B. DOGON

In the same region, the more contemporary Dogon consider duality to be inherent in every individual. The Dogon conceive of the soul as twin male and female spirits. According to Dogon theories concerning human development, we all come into the world with a single physical being that is accompanied by this bipartite spiritual dimension (Griaule 1947, p. 425). An individual's male or female gender is isolated and embraced at the time of circumcision or excision, operations that are believed to remove the female element from males and vice versa. Barbara DeMott (1982, p. 151) has suggested that the dynamic of paired opposition or dichotomies that characterizes the balanced union of the sexes underlies Dogon social relationships, ritual organizations and sequences, myth, and art.

In the most frequently recounted version of the Dogon myth of origin, the god Amma's first creation is a single destructive being known as the pale fox. This act is followed by the creation of four pairs of beings, or Nommo, who have been described as androgynous couples each embodying sexual equilibrium (ibid., pp. 32–33). Metaphors for social order and creativity, they are associated with introducing to humanity the essential arts of smithing, weaving, and agriculture. This emphasis on dualisms has been articulated extensively in visual forms of expression. On the most basic formal level, Dogon sculptors generally have emphasized bilateral symmetry as well as juxtapositions of horizontal and vertical elements and of negative and positive space. On an iconographic level, androgynous figures that combine male and female attributes as well as figural couples and pairs are featured (ibid., p. 32). A classic treatment on Dogon doors for granaries, shrines, and *ginna,* the structure that serves both as residence of the oldest male descendant of the lineage founder and as ancestral shrine, includes a lock carved with a pair of figures at the summit of the bolt case and rows of simplified attenuated vertical figures carved in relief. Imagery such as that on the door seen in plate 4 has been interpreted as representing the founding couple of a lineage in a field of male and female twins associated with fertility (Cole in Visonà et al. 2001, p. 140). In Dogon society, twins are accorded an elevated status: They are endowed with the *nyama,* or vital force of spirits, which brings prosperity and fertility to their families (Ezra 1988, p. 51).

I C. BAMANA

Neighboring Bamana and Maninka peoples also conceive of the human soul and body in terms of a fundamental duality. Each individual's *ni,* or soul, has a *dya,* or spiritual double (Imperato 1975, p. 52). Both of these are transferred to a newborn from an individual who has died immediately before the birth.

The *dya* is represented by one's shadow or reflection in the water or in a mirror. It may separate itself from the *ni* to circulate on its own, and is especially vulnerable to sorcerers and malevolent personalities. Duality also informs the identity of the androgynous divinity Faro, whom the Supreme God charged with perfecting the world and setting it in equilibrium (Zahan 1974, p. 3).

Twins, said to constitute each other's *dya,* are viewed as offspring of Faro, who confers invulnerability upon them (Imperato 1975, pp. 52, 59). Extraordinary beings that are considered a divine gift to their parents, the birth of twins is received with rejoicing. Twins are believed to use their special powers toward benevolent ends, including settling disputes and predicting the future. Until twins reach puberty, individuals may present them with weekly gifts, considered as offerings to Faro, in the hope of obtaining their blessings. A twin's death in childhood is the source of great sadness in the community. The child's father commissions a blacksmith to carve a commemorative figure as a material support for its *nyama,* or character (ibid., p. 53; Ezra 1986, p. 10). Such works, which may range in scale from a couple of inches to a foot, are called *flanitokele,* which means "twin [or double] that remains." The wooden figure is the same gender as the twin child that it is meant to evoke and is given his or her name.

A *flanitokele* is carved for the twins' mother until the living twin undergoes either circumcision or excision. At that transition to adulthood, the surviving twin assumes responsibility for the sculpture (Ezra 1986, p. 10). The figure is often dressed, decorated with jewelry, and presented with gifts comparable to those bestowed upon the living twin (Imperato 1975, p. 54). When the surviving twin marries, the figure is also provided with a spouse in the form of a companion sculpture of the opposite sex. From that time on, the two works are kept

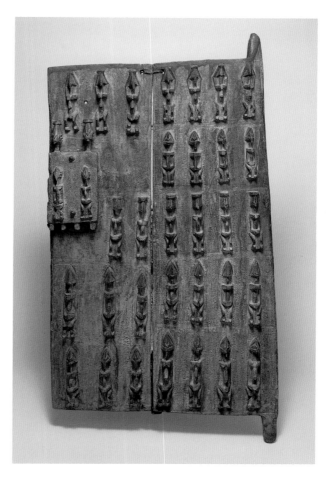

PLATE 4 Granary Door and Lock. Dogon peoples, Mali, 19th–20th century. Wood, 23$^{1}/_{4}$ x 17 in. (59.1 x 43.2 cm). Clyman Collection

together (ibid., p. 55). The male and female pair seen in plate 5 were created in keeping with this tradition. The arms of both standing figures terminate in broad paddle-like hands that face down and are held at their sides. Their faces are narrow, and their angular features are dominated by an arrow-like nose. The male wears a conical hat composed of a series of superimposed horizontal tiers; the female's elaborate coiffure consists of three parallel vertical ridges that span the width of her head. Her contours repeat those of her male counterpart to more dramatic effect. Conical breasts at the summit of her chest and pronounced buttocks extend the

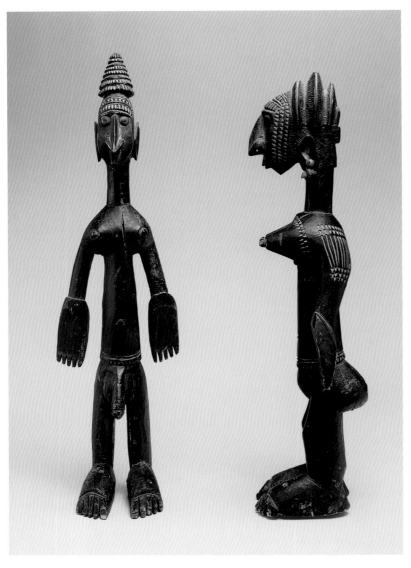

PLATE 5 Male and Female Twin Figures (*Flanitokele*). Bamana peoples, Segou region, Mali, 19th–20th century. Wood, H.: Male 21³/₄ in. (55.1 cm), Female 22³/₄ in. (57.8 cm). Collection Laura and James J. Ross

of styles are known, but that it is difficult to identify single twin figures on the basis of their formal qualities.

I D. SENUFO

Scholars have suggested that the Senufo of present-day Côte d'Ivoire were once part of the cultural conglomerate that occupied lands associated with Mali's Inland Niger Delta over a millennium ago (Glaze in Barbier 1993, vol. I, p. 30). The fundamental partnership of man and woman is a dynamic that is clearly articulated and underscored in Senufo social institutions and in their related forms of artistic expression. Male and female sculptural couples are the emblematic art forms of the principal Senufo social institutions: the female Sandogo and the male Poro associations. This cultural ideal is also evident in Senufo accounts of genesis in which Kolotyolo sets life in motion with his creation of a first man and woman who become parents to the first children, a set of male and female twins (Glaze 1981, p. 72). In Senufo society, twins are associated with supernatural powers that may be directed toward positive or negative ends. They derive this influence from the fact that they have closer ties with the spiritual realm than do ordinary mortals. In order for them to be a force for good, however, twins must reflect the ideal sexual balance of male and female of the creation myth (ibid.). This concern for equilibrium is ensured by an elaborate set of rules and ritual precautions concerning their equal treatment in order to avoid arousing jealousy between them (ibid., p. 73).

Anita Glaze (ibid., p. 46) has emphasized that Senufo women assume a greater role as ritual intermediaries between humankind and the spiritual realm than do their male counterparts. The largely female leadership of Sandogo is responsible for managing the quotidian relationship between individuals and spirits (ibid., p. 54). Among the various spirit

form. An abstract motif of bands of incised triangles is used as a unifying visual accent throughout. There exists a corpus of formally similar female figures attributed to the atelier of a Segou master, and some of these works may have been created for use in initiation rites. Couples in this style, however, are relatively rare. Kate Ezra (1986, p. 10) has noted that Bamana twin figures in a wider range

entities that communicate through diviners known as Sando are *ngaambele,* or twins that are considered a special sub-group of ancestors (ibid., p. 72). Given the intimate nature of the exchanges between Sando diviners and their clients, their consultation chambers are small spaces that dictate the modest scale of the sculptural works they integrate into their practice (ibid., p. 43). While Sando diviners of great repute may accumulate extensive displays of artifacts that reflect their prestige and success, at a minimal level their equipment must include either a cast-brass figurine depicting a couple or a carved-wood male and female sculptural pair. The ideal beauty of such couples attracts the nature spirits that they honor, inducing them to share divine insights with the Sando during divination sessions.

The efficacy of these pairs depends upon their aesthetic appeal, which explains why such works rank among the finest and most subtly rendered Senufo sculptural genres; this is exemplified by the figures seen in plate 6. The dynamic presence of this couple is accented by the reflective oiled surfaces, and their powerfully designed physiognomies endow them with a monumentality that belies their scale. Formally, the figures' vertical trunks are traversed by a series of graceful horizontal arcs. This is apparent in the contours of their crests, heads, and buttocks, and in the female's breasts. Both figures hold their hands before their abdomens. The male's proper left hand grasps a vertical staff with a curved tip that rests on his shoulder. The female is slightly more dominant, given her massive breasts and broad shoulders. Her head is crowned by a vessel balanced on a sagittal coiffure, while an elegant crest composed of three angled bands surmounts the male's head.

The male leadership of the Poro association is charged with sponsoring rituals and instruction that maintain respect for the ancestors and their values (ibid., p. 93). The intersection of

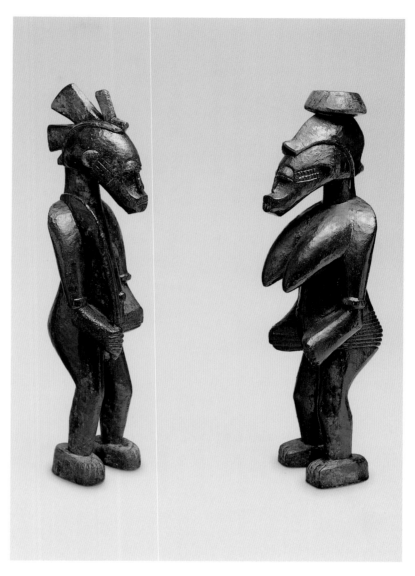

PLATE 6 Diviner's Figures: Couple. Senufo peoples, Côte d'Ivoire, 19th–20th century. Wood, H.: Male 15 in. (38.1 cm), Female 15¹/₂ in. (39.4 cm). Collection Laura and James J. Ross

this male sphere of influence with that of women is apparent in the Senufo mask genre known as *kotopitya.* Worn by Poro initiates in Senufo Fodonon farming groups, *kotopitya* masks are prescribed by a Sando diviner to female patrons who commission and then own them (ibid., p. 222). The mask, in turn, is provided to male Poro initiates who wear it in the performance of a dance known as *koto*

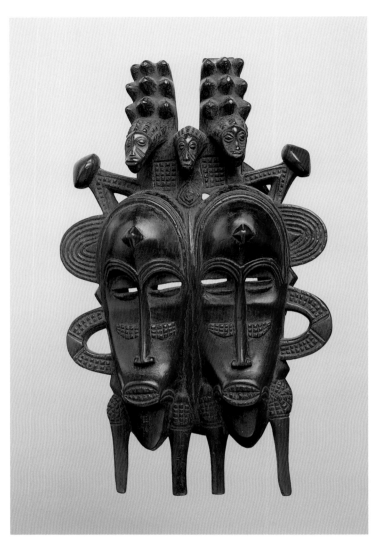

PLATE 7 Mask: Two Faces (*Kotopitya*). Senufo peoples, Côte d'Ivoire, 19th–20th century. Wood, H. 12⁵/₈ in. (32 cm). Collection Laura and James J. Ross

While the dancer that animates *kotopitya* is male, the form of the sculptural element designed to personify it is characterized as feminine. The basic structure is that of a relatively delicate and finely carved oval face mask that is slightly smaller than lifesize. The exceptional example seen in plate 7 is an especially accomplished interpretation in which the ideal of male/female collaboration is articulated through double faces. In this composition, bilateral symmetry is emphasized throughout. At its core is a pair of identical narrow faces that are framed by a series of vertical, triangular, and semicircular projections that extend around the perimeter. A unified aesthetic is achieved by repeating graphic elements from the face to enhance the lateral features. The middle such feature represents the "ear," while the upper and lower ones are simply "decoration." The concave visages each have a pronounced forehead and mouth and are bisected by the long vertical ridge of the nose that is the point of intersection of the arched eyebrows. These are articulated as a series of superimposed linear ridges that recur as an abstract pattern on the upper projecting tabs. The horizontal bands of raised, rectangular cicatrization markings on either side of the noses are repeated as an accent that enhances the lower tabs' contours as well as other points around the perimeter. At the summit, a crest composed of two vertical elements incorporates three miniature heads. The central one is positioned at the point of intersection of the two faces and looks forward, while the lateral ones are oriented outward. At the base, the pair of vertical, tapering peg-like pendants that extends from either side of each chin is said to denote a stylized rendering of a traditional women's coiffure. Sometimes referred to as "girlfriend," the abstract elegant design of such works is meant to evoke the ideal beauty of youthful womanhood (ibid., p. 127). Timothy Garrard (in Barbier 1993, vol. 2, pp. 103–4) has sug-

during the funeral rites of initiated men. The genre is ultimately defined by the choreography, instrumental accompaniment, song, and costume that Poro contributes to animate the mask. When not in use, the mask is stored by its female owner, who sends it annually to the bush to honor the *madabele,* or bush spirits, that it was created to appease. Glaze (ibid., p. 79) has noted that such a mask constitutes a kind of bridge and primary point of connection between Poro and Sandogo.

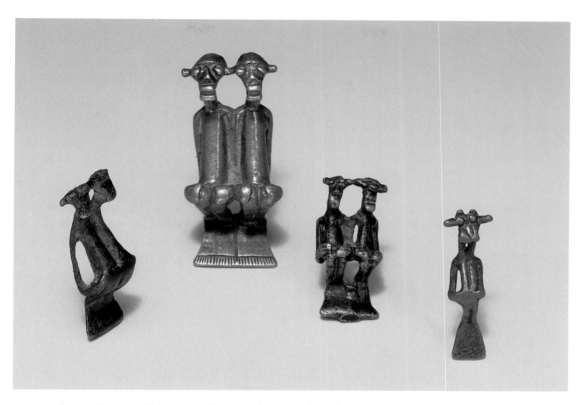

PLATE 8 Couple Figurines. Kulango peoples, Côte d'Ivoire, 17th–18th century. Brass (from left to right):
a. H. 1¹/₁₆ in. (2.7 cm); b. H. 1³/₄ in. (4.5 cm); c. H. 1¹/₁₆ in. (2.7 cm); d. H. 1¹/₄ in. (3.2 cm). Collection Brian and
Diane Leyden

gested that Senufo sculptors may have appropriated and then modified the design of double-face masks from a Diula masquerade prototype known as *do*.

1 E. KULANGO

A corpus of cast-brass miniature figurines stylistically related to those of the Senufo has been attributed to the Kulango of northeast Côte d'Ivoire, near the border with Ghana (Itzikovitz 1975, p. 9). A few examples of Kulango miniatures cast in gold appear to have been dispersed from the region, through trans-Saharan trade, as far as Egypt. A cache of ten such works also was found buried at an oasis in Queddan, Libya, in 1929. Striking for their delicacy and inventive formal variations on representations of couples, their design is at once minimalistic yet lyrical, as the examples

in plate 8 reveal. With heads thrust forward, backs arched, hands positioned on bent knees, and feet joined on a trapezoidal base, they are suggestive of ciphers for elemental notions of duality. Their distinctive stylistic approach to figuration emphasizes broad foreheads, the faces tapering to squared jaws, and prominent knobs extending out at either side as ears. Among the many different formal solutions used to depict couples are versions in which the two figures' torsos or heads are joined, or two bodies share a single head. Each of these variations merges the two figures so seamlessly that they suggest a single being. According to Timothy Garrard (in Barbier, vol. 2, p. 394), the Kulango brass miniatures take the form of bush spirits and are worn as pendants known as *hanyedio*; other regional sources have referred to them as "effigies of the soul" (Itzikovitz 1975, p. 9).

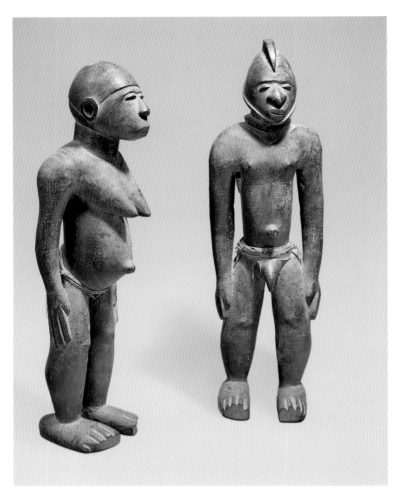

PLATE 9 Female and Male Shrine Figures (*Bateba*). Lobi peoples, Burkina Faso, 19th–20th century. Wood and fiber, H.: Female 20^1/$_2$ in. (52.1 cm), Male 21^1/$_2$ in. (54.6 cm). Private collection

I F. LOBI

In Burkina Faso, Lobi sculptors create male and female figural couples for use by professional diviners and for domestic shrines. In Lobi society, immaterial spiritual divinities, called *thila,* are responsible for overseeing a community's well-being (Meyer 1991). In their efforts to maintain political, social, and moral order and provide protection against witchcraft and sorcery, *thila* communicate through diviners they have selected as intermediaries. When an individual consults a diviner concerning misfortunes inflicted by

spirits, *thila* may direct that a shrine figure be carved as part of the remedy and provide the formal requirements for its appearance. The sculptural works created for residential or public shrines may suggest a physical form for the *thila*. Known as *bateba,* they afford an extended family a protective line of defense, preventing the entrance of evil into a household (Meyer 1981a, p. 33).

The Lobi couples that serve diviners in their practice are relatively small in scale compared to the example in plate 9, which was intended for placement on a residential shrine (Skougstad 1978, p. 31). Both man and woman are portrayed in the same bold, immovable stance, with facial expressions that purposefully intimidate in order to frighten away harmful forces. They stand with arms at their sides, hands resting on their thighs, and their strong powerful legs are supported by broad feet. The male figure is slightly taller, his head crowned by a sagittal crest, and he is distinguished by his elongated torso. In contrast, his female counterpart's trunk accentuates the curved projections of her breasts and stomach.

I G. BAGA

The oral traditions of the Baga, Bidjogo, and related peoples who live at the western end of the Guinea Coast describe their migrations from the Sudan to their present settlements in Guinée and Guinée-Bissau. Given those historical ties, their cultural heritage has been included in the rubric of Sudanic artistic traditions (Vogel 1981, p. 53). A powerful reflection on duality is expressed by Baga sculptors through D'mba couples, as seen in the example in plate 10. The upper portions of these male and female representations both relate to a colossal headdress in the form of a female bust also known as D'mba. The possession of male elders, D'mba headdresses were worn at per-

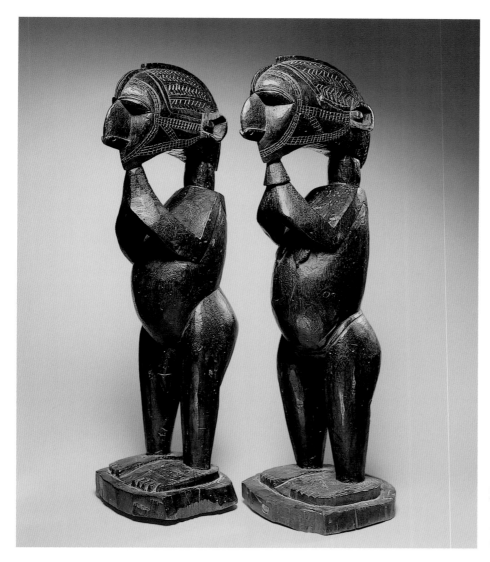

PLATE 10 D'mba Couple. Baga peoples, Guinée, 19th–20th century. Wood, H.: Male 26 3/8 in. (67 cm), Female 27 3/16 in. (69 cm). High Museum of Art, Atlanta. Fred and Rita Richman Collection (2002.281.1-2)

formances on occasions that marked milestones of individual and communal growth such as marriages, births, wakes, ancestral commemoration, and planting and harvest festivals (Lamp 1996, p. 171). While the freestanding figures may represent a sculptural genre of even greater antiquity, over the last century the performance of D'mba headdresses has been the more dominant of the two traditions and more extensive commentary exists on its significance.

D'mba figurative pairs combine fantastical otherworldly visages with humanized bodies. Except for their exposed genitalia and the female's flattened pendulous breasts, the figures are otherwise identical. According to interpretations of D'mba headdresses, the pendant breasts are references to the selfless dedication of motherhood. Both male and female have an identical massive head supported by both the neck and the hands, which are raised to the base of the chin. A dominant beak-like nose projects dramatically forward, while the mouth is not articulated at all. The incised linear designs on the sides of each head represent intricate

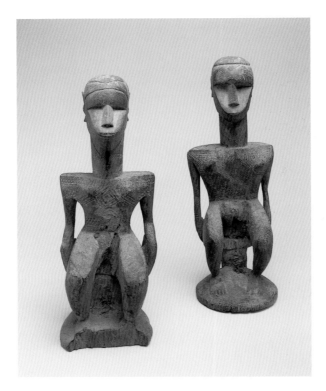

PLATE 11 Seated Male and Female Figural Pair. Bidjogo peoples, Bissagos Islands, Guinée, 19th–20th century. Wood, H.: Male 14⁷/₈ in. (37.8 cm), Female 15³/₄ in. (40 cm). Schorr Family Collection

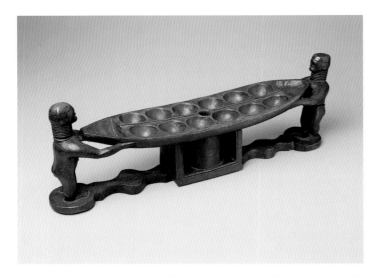

PLATE 12 Mankala Game Board with Figural Pair. Bidjogo or Bulom (?) peoples, Guinée-Bissau or Sierra Leone, 19th–20th century. Wood, 6 x 3¹/₄ x 3³/₄ in. (15.2 x 8.3 x 9.5 cm). Brooklyn Museum of Art, New York (22.239)

rows of parallel braids that, combined with the crowning crest, depict an elaborate coiffure associated with Fulbe women of high status (ibid., p. 176). This exotic attribute of Fulbe style was adapted as a result of Baga admiration for the refinement and elegance of Fulbe feminine adornment. Not only does it distance D'mba from ordinary Baga experience but it confers upon the latter an association with power, given the Fulbe's dominance within the region (ibid., p. 179).

Frederick Lamp (ibid., p. 159) has emphasized that the larger-than-life D'mba representation is essentially a conceptual role model that members of Baga society strive to emulate. D'mba embodies the honored universal mother of many offspring who have attained productive adulthood: She is Woman at the zenith of her power, beauty, and goodness (ibid., p. 158). Although the D'mba masquerade represents a female icon, male and female D'mba figural couples reflect the notion that the Baga ideals it personifies are fundamentally shared by both men and women (ibid., p. 160). D'mba couples also have been associated with protective powers.

1 H. BIDJOGO

Bidjogo emphasis on figural pairs is evident in their most sacred creations as well as in their finely designed secular works. Couples depicted on U-shaped seats have been described as mediums through which a supreme divinity may be consulted. The figures seen in plate 11 are at once physically independent and complementary entities, their gazes slightly differentiated. Overall, the definition of the forms is rectilinear; they have squared torsos that taper at the waist and broad thighs that narrow at the ankles. Referred to as *ira*, such works belong to a broad category of natural and man-made artifacts that contain sacred energy.

Iras' powers are drawn upon in rites relating to agrarian fertility, marital blessing, and divination. In contrast, the elaborately carved *mankala* game board illustrated in plate 12 is a work of virtuosic artistry that relates to regional traditions of functional implements carved for wealthy patrons. Represented as a canoe-like vessel, it is held at either end by a standing male figure whose position echoes that of the players facing each other at opposite ends of the board.

II Yoruba Dualities

As sub-Saharan Africa's largest ethnic group, the Yoruba have been responsible for an artistic tradition that is at once among the continent's most diverse as well as prolific. Not only has Yoruba culture developed for nearly a millennium across a vast regional expanse of what is today southwestern Nigeria but it has had considerable influence across the Atlantic in the Americas, through the diaspora. Given the breadth and influence of Yoruba artistic expression, that tradition provides a rich case study for the examination of a series of distinct sculptural genres that relate to notions of duality within a single culture. The classic forms that will be considered are Eshu dance wands, *ibedji* figures, and *edan Osugbo* sculptures that articulate fundamental Yoruba philosophical, spiritual, and social precepts.

In Yoruba thought and belief, the conception of the cosmos itself is informed by ideas of duality. A bipartite sphere of existence, it has been described through the visual metaphor of a bisected gourd. The two cosmic realms consist of *aye,* the visible tangible world of the living, and *orun,* that of the ancestors, gods, and

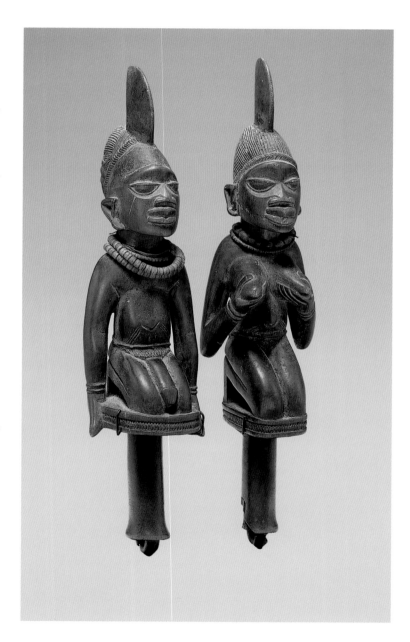

PLATE 13 Pair of Eshu Dance Wands: Male and Female Kneeling Figures. Yoruba peoples, Nigeria, 19th–20th century. Wood and beads, H.: Male 13³/₄ in. (34.9 cm), Female 14 in. (35.6 cm). Private collection

spirits (Drewal, Pembeton, and Abiodun 1989, p. 14). The two converge through divination rites known as Ifa. At the outset of an Ifa invocation, a priest alludes to the intersection of *aye* and *orun* by inscribing a pair of perpendicular lines into the chalky dusting of *irosun* powder on the surface of a tray positioned before him. The fundamental duality that informs Yoruba definitions of experience is also apparent on a microcosmic level in the person of each individual being. Every human is defined by an inner and an exterior head. *Iwa,* one's essential nature, and *ase,* life force, are situated within *ori inu,* the inner head, which influences and informs *ori ode,* the outer being, apparent to others (ibid., p. 26). Given that one's vitality and character are situated there, in sculptural representations Yoruba artists invariably have enlarged the head in relation to the rest of the body.

II A.

While all divinities in the Yoruba pantheon may manifest their presence in *aye,* Eshu, or Esu/Elegba, is designated as the intermediary between the human and spiritual realms. Given his engagement with and influence in both spheres as "divine messenger, facilitator, transformer, and provocateur," Eshu is associated with great dynamism (ibid., p. 25). His role as divine mediator is acknowledged prominently by the face carved at the apex of the rim of Ifa trays, which is positioned to watch over the priest during divination. Eshu's wife, Agberu, collects the necessary sacrifices made by human petitioners. Eshu subsequently presides over the transfer of offerings to the gods and the release or withholding of their blessings (Pemberton in Vogel 1981, p. 98). Although Eshu is always conceived of as male, his power often is given visual expression through male and female figurative pairs such as that shown in plate 13. According to John Pemberton (ibid.), such couples suggest Eshu's vitality

through "the tension and creative possibilities of human sexuality." The combination of complementarity and difference embodied by such couples serves as a metaphor for Eshu's capacity to bridge distinct realms of experience. This classic example represents both man and woman, with a prominent sagittal crest that projects vertically from the crown of each head. These crests are an attribute of Eshu. The male figure's arms extend downward at his sides but the female holds her breasts—a gesture of generosity that emphasizes the nurturing role of women. Depicted kneeling in an attitude of deference, the figures also evoke the Eshu devotees who wield such artifacts as dance wands in ritual performances.

II B.

The Yoruba have one of the highest incidents of twin births in the world—a phenomenon attributed to diet and genetics (Pemberton in Drewal, Pemberton, and Abiodun 1989, p. 170). In Yoruba society, twins are regarded as extraordinary beings protected by Shango, the god of thunder. Powerful spirits in life, twins become divinities when they die. Pemberton has noted that in the Oyo region, twins are believed to be capable of bestowing immense wealth upon their families and directing misfortune to those who neglect or offend them (ibid.). Parents of twins lavish them with special attentions that include honoring them with gifts, songs, dances, and special foods. It has been suggested that this reverence for twins developed in southwestern Yorubaland during the mid-eighteenth century and that it gradually spread to eastern and northern regions (Fagg 1982, p. 80). These attitudes may have displaced earlier negative associations and practices such as twin infanticide.

Upon a twin's death, he or she is honored with a carved memorial figure known as *ibedji.* Should a pair of twins die, a matching set of figures is commissioned. Consequently, *ibedji*

figures are conceived either as single works or as pairs depending on the circumstances that lead to their creation. Parents of a deceased twin will consult an Ifa divination priest in order to determine by whom the *ibedji* figure should be carved (Pemberton in Drewal, Pemberton, and Abiodun 1989, p. 171). The sculptor is then essentially responsible for determining the *ibedji*'s design, and, upon its completion, will invoke its spirit by submerging the figure in a solution of crushed leaves and water; once dried, it is rubbed with a mixture of palm oil and shea butter. In the care of the family that commissioned it, the work becomes a surrogate for the attention and affection that family members once bestowed upon the child the figure memorializes, as well as a locus for its *ase* (Pemberton in ibid., p. 173). Ritual care is provided by either the mother or the surviving twin, who bathes, dresses, and feeds the *ibedji*.

While the *ibedji* figures produced by an individual Yoruba master and his workshop may not necessarily vary a great deal formally from one commission to another, each figure is inextricably tied to the memory and identity of the individual it commemorates. *Ibedji* invariably represent their subjects with mature adult physiognomies. The pair seen in plate 14 is also typical in the emphasis accorded the head, which is crowned by an elaborate conical coiffure that constitutes a third of the body. The extreme exaggeration gives the figures an otherworldly appearance that reinforces their spiritual identity. Exceptional for the delicacy of their features, the male and the female are rendered virtually identically. Their dynamic formal interaction suggests that they may be about to begin dancing.

II C.

Another quintessential Yoruba sculptural tradition that emphasizes ideas of duality is the brass castings known as *edan Osugbo,* insignia

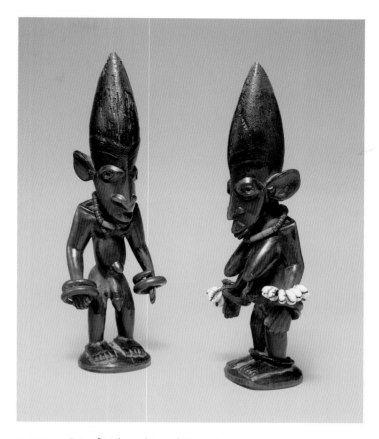

PLATE 14 Pair of Male and Female Twin Figures (*Ibedji*). Yoruba peoples, Nigeria, 19th–20th century. Wood and beads, H.: Male 11³/₄ in. (29.8 cm), Female 11¹/₄ in. (28.6 cm). Private collection

of the society of a community's male and female elders. Osugbo is one of the Yoruba's most important institutions, serving a wide range of political, judicial, and religious functions, which include the selection, installation, and burial of kings. Osugbo members also render judgments in criminal cases and abuses of power (Abiodun, Drewal, and Pemberton 1991, p. 26). It has been suggested that the institution originated among the Ijebu Yoruba of the southern coastal area in the sixteenth or seventeenth century and that it was adopted by the Egba Yoruba to the west and the Oyo to the north, where it is referred to as Ogboni (ibid., p. 22). Osugbo society members transcend divisions and oppositions that inform ordinary life to

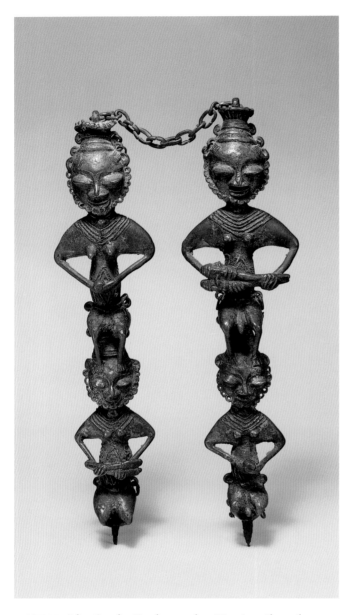

PLATE 15 *Edan Osugbo.* Yoruba peoples, Nigeria, 19th–20th century. Brass, H. (each) 13¹/₂ in. (34.3 cm). Collection Laura and James J. Ross

acknowledge a fundamental unity in human experience (Fagg 1982, p. 186). The gender differences and familial ties that once distinguished Osugbo titleholders from one another dissipate in their advanced years, and are discarded in favor of "the underlying unity of all life" (Abiodun, Drewal, and Pemberton 1991, p. 22). Osugbo members strive to obliterate dualities and, in so doing, to attain the ultimate level of enlightened consciousness. The art form bestowed upon them at the time of their induction into the society likewise unifies male and female elements and thus is considered greater than the sum of its parts. This ideal is expressed by the aphorism "Two [Osugbo], it becomes three."

Edan Osugbo, seen in plates 15 and 16, consist of a pair of male and female figures—representing a community's founders and an alliance of opposites (Cole in Visonà et al. 2001, p. 53)—joined at the summit by a chain. The chain that links these elements underscores the idea of a sacred bond that unites all male and female Ogboni members (Drewal, Pemberton, and Abiodun 1989, p. 140). The fact that its point of connection with each of the figures is the crown of the head reflects the Yoruba emphasis on the head as the repository of spiritual and intellectual qualities. In the example seen in plate 15, paired images are amplified by the bilateral symmetry of the two separate *edan* elements as well as by the echoing imagery across both the horizontal and vertical registers. The idea of paired unity is suggested through a double-tiered composition. The two seated figures on the upper level are almost mirror images of one another; their feet rest on the foreheads of the kneeling figures below them that are slightly smaller in scale.

While the figures' bodies distinguish them as male and female, their heads are identical. As is typical in *edan* representations, the relative spareness of the bodies contrasts with

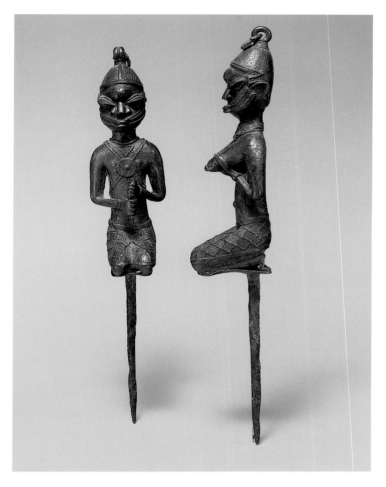

PLATE 16 *Edan Osugbo*. Yoruba peoples, Nigeria, 19th–20th century.
Brass, H. (each) 13 in. (33 cm). Collection Laura and James J. Ross

the scale of the dominant heads, "swollen with the power of their wisdom" (Abiodun, Drewal, and Pemberton 1991, p. 23). The proper right figure in the upper tier has a female torso and holds her left fist over the right one, with thumbs concealed, in front of her abdomen. The proper left figure, a male, cradles a pair of *edan* horizontally across his abdomen. The female's gesture is distinctive to Osugbo and is variously interpreted as the blessing "may you live long and prosper" and as a greeting that stresses the hidden information shared by Osugbo members (Drewal, Pemberton, and Abiodun 1989, p. 140). The figures in the lower tier repeat in reverse order the gesture of the pair above. Their kneeling postures refer to a traditional Yoruba form of Osugbo greeting that at once conveys respect, obedience, deference, and devotion (ibid.). The act of kneeling is also associated with the moment when the High God Olodumare confers an individual's destiny upon him in preparation for entering a world of conflict (Fagg 1982, p. 186).

III Insignia of Leadership: Power Couples

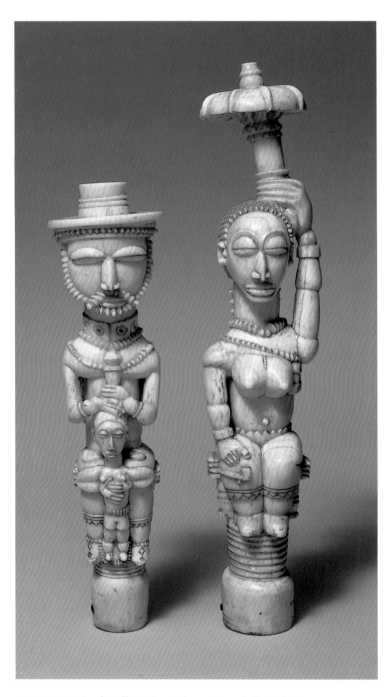

PLATE 17 Pair of Staff Finials: Male and Female Seated Figures. Attie group, Lagoons peoples, Côte d'Ivoire, 17th–18th century. Ivory, H.: Male 5⁷/₈ in. (15 cm), Female 7¹/₁₆ in. (18 cm). Collection Laura and James J. Ross

Couple imagery in numerous African sculptural traditions constitutes an ideal of cultural refinement and elegance designed to enhance the prestige of distinguished patrons. In many distinct societies, the elite, who range from wealthy and influential individuals to spiritual intermediaries and leaders, commission figurative pairs as metaphors for their divinely sanctioned power. Such dual representations give expression to both the temporal and the spiritual dimension of their patrons' exalted nature and association with abundance. The prestige these works confer upon their owners derives at once from the vision of harmonious equilibrium they articulate as well as from the exceptional level of artistic accomplishment they exemplify. Such attributes of leadership may run the gamut from precious miniature ivory finials that underscore the interrelationship of affluence, spiritual power, and political influence of an Attie leader to the monumental thrones encrusted with costly beadwork that are the ultimate symbol of a Grassfields sovereign's legitimacy. While the visual language used to denote power often may take the form of male and female couples, in some traditions comparable ideas and associations may be expressed through same-sex pairs.

III A. LAGOONS

A cluster of a dozen ethnic groups known as Lagoons live along the coastal waterways and the inland hills of southwestern Côte d'Ivoire. While Lagoons societies are mainly egalitarian, relatively affluent dignitaries distinguish themselves with costly textiles and emblems of status and authority made of precious materials (Visonà et al. 2001, p. 201). Ownership of remarkable artifacts in luxury materials impresses the community and implies that

one has enjoyed the favor of the spiritual ancestral realm (Visonà in Barbier 1993, vol. 1, p. 376). Lagoons societies conceive of affluence, leadership, and spiritual power as interrelated. Within the Lagoons region, traditional Attie and Abure leaders were entitled to half of the tusks obtained from the elephant hunt (ibid., p. 374); as a result, these influential individuals commissioned rare ivory artifacts such as finely wrought finials for staffs of office, which they displayed as emblems of status at public gatherings (ibid., p. 375).

The male and female couple seen in plate 17, attributed to an Attie carver, is part of a small corpus of less than a dozen ivory miniatures created as staff finials. They have been dated to sometime between the seventeenth and eighteenth century, the time of the earliest contact between European and coastal Lagoons groups (ibid.). This regal pair, depicted with eyes closed, is seated on elaborately carved throne-like chairs. The approach of the carver was highly detail oriented both in terms of the figures' apparel and their physiognomies, which are described as discrete volumes. The female figure wears gold beaded necklaces and her head is crowned by an elaborate coiffure but she is otherwise nude. Her proper left arm is raised and she holds a parasol in her hand. Her bearded male counterpart wears a bowler-like hat, a collar, and several strands of beads but his torso is exposed. He clasps a staff of leadership with both hands, which rest on the head of the miniature attendant figure standing in front of his lower body.

The same formal imagery is evident in the iconography of an Abure wood pillar carved for the regional chief Acka and documented in a mid-nineteenth-century drawing by the Frenchman Hecquard (Mark 1987, pp. 56–59; Visonà in Barbier 1993, vol. 1, p. 375). The imagery on Chief Acka's pillar

was arranged in a series of superimposed tiers beginning at the base with a similarly attired standing male figure wearing a hat and flanked by a female companion shielding them both with a parasol. Most of the other known Attie ivory finials consist of single seated male leaders in European attire, with one notable exception: That work, in the Musée Barbier-Mueller, Geneva, features a double-tiered composition of paired figures in which two seated males appear arm in arm facing forward at the summit of a platform that is supported by the raised arms of a pair of females with their backs to one another (Visonà in Barbier 1993, vol. 1, p. 375). Visonà (1990, p. 60) has suggested that the male subjects depicted on staff finials and pillars may represent their owners and ancestors; the European top hats and umbrellas often included were associated with commercial trade, and are metaphors of status, wealth, and prestige (Mark 1987, p. 58).

Lagoons carvers were responsible, too, for other sculptural traditions that give expression to cultural ideals of duality. When a twin died, a portrait was commissioned by the family. This allowed them to maintain a special relationship with the spirit of the surviving twin (Visonà in Barbier 1993, vol. 1, p. 377). Lagoons peoples also share with their northern neighbors, the Baule, the belief that every individual is essentially paired with an ideal partner of the opposite sex, or "spirit spouse," that resides in a parallel spiritual realm, or *blolo*. In Baule thought, *blolo* exists in contrast to the physical world and is the abode of one's otherworld "spouse" as well as of the departed dead and the spirits of the unborn (Ravenhill 1980, p. 2). Susan Vogel (1997, p. 168) has indicated that opposite-gender doubling is a fundamental aspect of Baule art in which two figures do not necessarily merely represent complementary beings but may be manifestations of a single being.

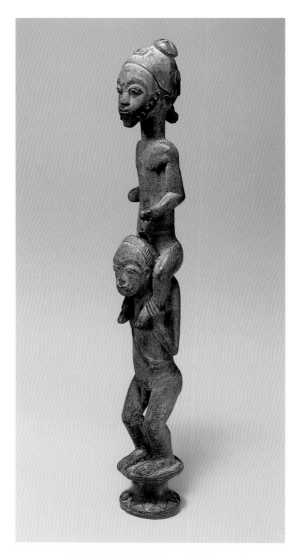

PLATE 18 Diviner's Double Figure. Baule peoples, Côte d'Ivoire, 19th–20th century. Wood, H. 18⅛ in. (46.1 cm). Collection Drs. Daniel and Marian Malcolm

She has noted that "in some sense the spirit spouse is an alter ego, a sort of opposite-sex twin of its human partner" (ibid., p. 267), further observing that, as in other African traditions, this suggests the idea that humans embrace elements of the opposite sex within themselves (ibid., p. 185). That theory of individual identity informs the creation of Baule figurative sculptures as inverted reflections of their patrons honoring their spirit spouses.

III B. BAULE

In Baule society, another form of spiritual partnership may join a man, woman, or child with a bush spirit, or *asye usu*. Great numbers of *asye usu* are believed to populate the natural world and are conceived of as opposites of the ideal Baule member of society (ibid., p. 239). In contrast to a Baule's aspirations to be productive, industrious, prosperous, and orderly, bush spirits are described as destructive, capricious, eccentric, and unkempt. Bush spirits may elect to attach themselves to an individual who fulfills a special calling as a diviner by serving as their medium while he or she is in a trance-induced state (ibid., p. 224). Diviners strive to tame *asye usu* in order to divert their energy to help people and obtain valuable insights. Toward this end sculptural works are created to localize their immaterial presence. Such works serve as a "stool" that the spirit may "sit" upon and are physically identified as doubles of their owners since the *asye usu* may alternatively inhabit either the diviner or his or her sculptural counterpart (ibid., pp. 232–39).

Vogel has noted that only the most established trance diviners own finely carved sculptures. These serve to enhance their owner's professional standing and to generate public interest and excitement in a divination session (ibid., pp. 221, 232). As public statements that announce a diviner's success and accomplishment, such works rank among some of the most elaborate and original examples of Baule sculptural creations (ibid., pp. 221, 230), and their idiosyncratic imagery may dramatically underscore the nature of the diviner's partnership with the *asye usu*. Vogel has interpreted the pairing seen in plate 18 — a work that depicts two male figures, one seated on the other's shoulders, with the standing figure, in turn, balanced on a stool — accordingly: She notes that the latter wears a bandolier with an animal horn similar to those worn by diviners and suggests that the

upper figure may represent the *asye usu* that has "fallen upon" him (ibid., p. 222).

III C. KINGDOM OF BENIN

At the court of Benin in present-day Nigeria, elite guilds of artists specializing in such mediums as brass casting created a broad spectrum of works designed to enhance and reflect upon the exceptional status of their semi-divine sovereigns. According to Benin cosmology, existence is informed by a fundamental duality in which the tangible world of the living coexists with a parallel spirit world (Blier 1998, p. 64); the ocean is said to constitute a boundary between the two. The fifteenth-century leader Ewuare, a larger-than-life figure in Benin history, is credited with shaping the divine character of Benin kingship. According to oral tradition, Ewuare went down to the Ughoton River, where he stole beads belonging to Olokun, god of the waters. In bringing them back to Benin, he assumed the role of Olokun's earthly counterpart. Between 1472 and 1486, during Ewuare's reign, Portuguese traders arrived in Benin from across the sea. Given the wealth and prosperity that their trade relationship conferred upon Benin's leadership, their depiction in court art becomes the dominant visual metaphor for royal affluence and power.

In the densely packed imagery of the finely cast mace finial seen in plate 19, a leopard—personifying at once Ewuare and Benin kingship—is flanked by a pair of Portuguese traders. Leopards, sometimes in pairs, are a metaphor for the royal power of kingship in Benin art. A creature identified with speed and danger, the leopard is specifically associated with ritual acts performed at a Benin king's coronation as well as with annual rites dedicated to the king's mystical powers. According to oral tradition, a leopard appeared to the warrior king Ewuare before his ascent to the throne auguring his success-

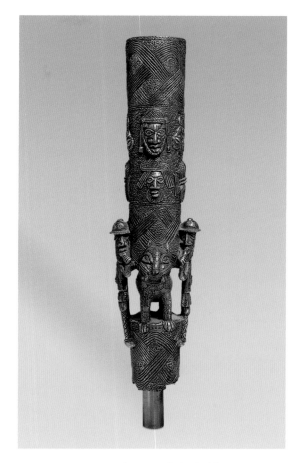

PLATE 19 Mace Head: Leopard Flanked by Portuguese. Edo peoples, Kingdom of Benin, Nigeria, 16th–17th century. Brass, H. 9¹/₂ in. (24.1 cm). Collection Laura and James J. Ross

ful reign. This formal arrangement evokes frequent depictions on royal architecture and in sculpture in which the king is supported on either side by a pair of priests, chiefs, or attendants at palace rituals. In some instances, scholars have identified the royal support figures as court priests representing the deities Ose and Osuan, who are associated with the protection of warriors and with healing (ibid., p. 52). On a general level, the configuration of paired attendants has been interpreted as expressive both of the support from which the king benefits as well as of the restraints upon his powers.

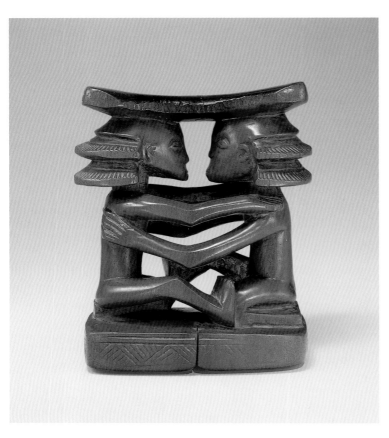

PLATE 20 Headrest: Female Couple. Luba peoples, Democratic Republic of the Congo, 19th–20th century. Wood, H. 7¼ in. (18.4 cm). Collection Drs. Daniel and Marian Malcolm

III D. LUBA

Imagery of female pairs enhances the full panoply of royal sculptural wood artifacts, which are associated with Luba authority and divinely sanctioned leadership. Mary Nooter Roberts has emphasized that Luba kingship is fundamentally informed by sexual duality (Roberts and Roberts 1996, p. 169). The critical role that Luba women historically performed as emissaries and advisors to kings, in addition to their extension of a chief's influence through marriage, is underscored in the female iconography of the emblems of male titleholders. In partnership with male leaders,

Luba women served as divine mediators. In Luba society, twin female spirit mediums personify the guardian spirits of kingship, or *vidye* (ibid., p. 44). They are represented in elite works such as the headrest seen in plate 20, whose horizontal element is supported by two seated female caryatids. Their embrace is similar to the interaction of female figures represented at the summit of some Luba staffs of office.

Roberts (ibid.) notes that in Luba society beauty is achieved through processes of perfecting the female body so that it may ultimately serve as a spiritual receptacle. It is this ideal of civilized beauty and elegance that is emphasized in Luba royal sculpture. The two female figures depicted in this work are essentially mirror images of one another. The parallel tiers of their coiffures are echoed in the overall composition, from the horizontal support that extends across the crowns of their heads to the arrangement of their limbs: Each figure places her outstretched arms on her counterpart's shoulders and rests her right leg on the other's bent left knee. This type of headrest protected complex hairstyles like the ones worn by the female caryatids depicted here. Known as *mikada,* the coiffure referred to as "cascade" or "steps" is characterized by layered tiers of hair covering a canework frame (ibid., p. 112); especially labor intensive, it required as many as fifty hours to arrange. Headrests were designed to support the back of the neck in order to preserve these elaborate coiffures, which were worn by members of elite Luba society during the last century.

III E. MANGBETU

Mangbetu figural works, such as the impressive standing couple illustrated in plate 21, appear to have been secular creations made for the appreciation of chiefs and other elite individuals,

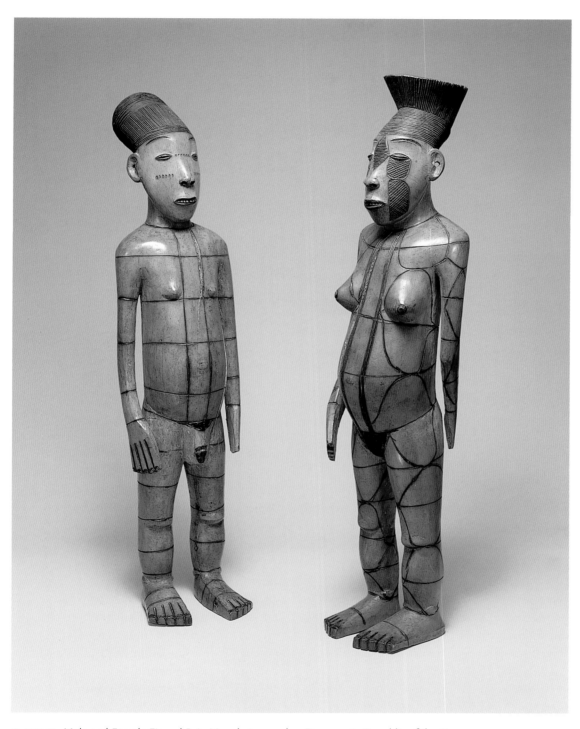

PLATE 21 Male and Female Figural Pair. Mangbetu peoples, Democratic Republic of the Congo, 19th–20th century. Wood, H.: Male 24$^{1}/_{2}$ in. (62 cm), Female 24 in. (61 cm). Private collection

including early Western patrons (Schildkrout and Keim 1990, pp. 237, 244). They portray the idealized beauty and aristocratic fashion of the Mangbetu of the late nineteenth and early twentieth centuries. The distinctive Mangbetu aesthetic exemplified by this couple emphasized an elongated head and elaborate coiffures. The style of the wealthy ruling class, it was achieved by modifying the skull through binding, wrapping string around the forehead and head, and drawing the hair around a basketry frame (ibid., pp. 124, 126). More ephemeral and varied was the body painting that women applied with a black juice made from the gardenia plant. The repertory of patterns created with stamps and by freehand painting was unlimited, and new designs were especially admired. A given application typically lasted a couple of days and was then rubbed off to be replaced with new designs (ibid., pp. 134, 133, respectively).

Early-twentieth-century Mangbetu sculptors also reproduced the signature elite configurations of the head at the summit of ceramic vessels (ibid., p. 245). Although the genre typically featured a single head, double-headed vessels such as the work shown in plate 22 also were produced. While the function of these double vessels is unclear, the bipartite form was derived from *naando* ritual pots used for ingesting a hallucinogenic beverage that gives rise to altered states of consciousness (ibid., p. 171). *Naando* is a ritual institution central to Mangbetu society, and also is the substance created from the root of a wild plant, consumed by members of that organization, and regarded as a power derived from the forest that is said to ensure successful hunting (ibid., p. 169). In most Mangbetu areas, specialists in the use of *naando* employed it to discern hidden information, predict the future, and safeguard the community's well-being (ibid., p. 170).

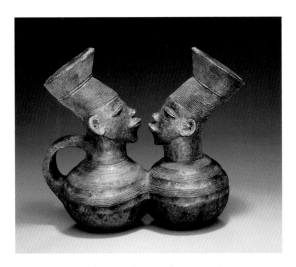

PLATE 22 Double Vessel. Mangbetu peoples, Democratic Republic of the Congo, early 20th century. Terracotta, H. 8⅝ in. (22 cm). American Museum of Natural History, New York (413 cat 90.1/4693A)

III F. CAMEROON GRASSFIELDS
Idealized royal couples are also a prominent motif in the art of the Cameroon Grassfields, a culturally unified region divided into autonomous kingdoms and chiefdoms. Among the most important of these is the densely populated Bamileke circle in the southwest, whose major polities and art-producing centers include Bandjoun, Batcham, Bangwa, and Bansoa. Each of these highly centralized chiefdoms is overseen by rulers known as *mfo* (sing., *fo*). In the Bamileke sphere, chiefly power depends on the *fo*'s ability to generate life within his domain. Dominique Malaquais (1999, p. 28) has noted that a Bamileke chief is considered to be responsible for procreation in the natural world and this life-giving power is an essential dimension of his identity. For this reason the replication of figurative and zoomorphic imagery is the prerogative of chiefly patronage.

The impressive art forms produced by Bamileke artists include the monumental cer-

34

emonial seats of office that incorporate figurative sculpture in the round. Sculptors and workshops at Bansoa and Bandjoun are credited with some of the more outstanding examples of Bamileke thrones (Perrois and Notué 1997, p. 160). A new chief rarely used the seat of office of his predecessor but instead commissioned his own. Special ceremonies surrounded his installation, and the throne itself often received annual ritual treatments. These works were not intended to serve as functional seats but were displayed ceremonially on such occasions as state visits, annual dances, or the king's funeral.

The extraordinary throne seen in plate 23 was documented at Bansoa by Pierre Harter in 1957. The back edge of its circular seat features two freestanding figures that have been identified as the king (on the proper right) and a royal wife. Louis Perrois and Jean-Paul Notué (ibid., p. 172) have suggested that the style of this work is characteristic of that of artists from the central and western part of the Bamileke plateau around Bansoa and Bafou. The royal couple is depicted with a series of insignia denoting their exalted status (Northern 1984, cat. 23, pp. 102–3). The king holds a drinking horn and wears a prestige cap, a loincloth fastened with a leopard-skin belt, bracelets, and a necklace. His wife's allegiance to him is indicated by the calabash from which she will serve him palm wine, and her identity as a royal spouse is alluded to by the circlet of cowrie shells that edge her coiffure; she wears bracelets, anklets, a necklace, and a belt. The platform upon which they stand is supported by a caryatid leopard. An emblem of the formidable power of kingship, the leopard is positioned in an aggressive stance and its claws and teeth are accented with white. The brilliantly colored beaded surface of the work is further enlivened by abstract, two-dimensional graphic motifs, among them lozenges that represent schematized frogs,

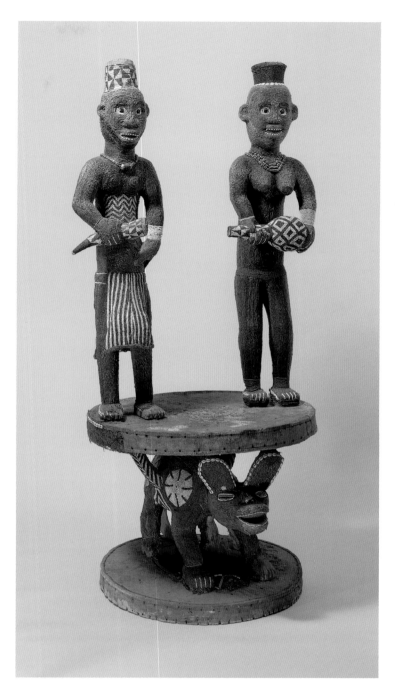

PLATE 23 Throne: Royal Couple. Bamileke peoples, Grassfields region, Bansoa chiefdom, Cameroon, 19th–20th century. Wood, glass beads, cloth, and cowrie shells, H. 63 in. (160 cm). Private collection

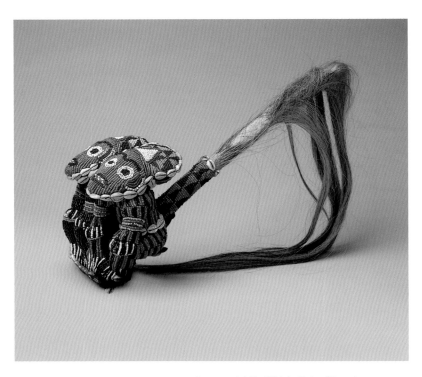

PLATE 24 Ceremonial Fly Whisk: Pair of Royal Attendants. Bamun peoples, Grassfields region, Cameroon, 19th–20th century. Wood, cowrie shells, horsetail, beads, and fiber, H. 20 in. (50.8 cm). Private collection

symbols of fertility and abundance. Beads were luxury materials obtained through long-distance trade and their use was the prerogative of the ruling elite. While beads were the ultimate statement concerning prosperity, lavish, beaded surfaces are also associated with fertility (Malaquais 1999, p. 29). In addition to serving as the focal point of seats of office, freestanding memorial figures depicting the king and his wife were created for display on occasions ranging from ancestral commemorations to prayers for the protection of the chiefdom and the fertility and fecundity of the earth (Perrois and Notué 1997, p. 168).

A series of related Bamileke thrones from other centers also depict figural pairs. One such work from Bandjoun similarly features a leopard caryatid at the base, which supports two standing figures. There, however, the couple represents two of the king's counselors and retainers (ibid., p. 160). The substitution of idealized royal spouses for paired guardian attendants in Grassfields regalia is widespread in works from the kingdom of Bamun, which is situated northeast of the Bamileke. The most important and impressive emblems of kingship at Bamun also were thrones. A standing male and female couple at the back of the celebrated throne of the Bamun king Njoya represents court twins. Although their identities differ, the iconography is very similar to that of the Bansoa throne, with the male figure on the left shown holding a drinking horn and the female a calabash bowl; the principal variation is their gestures of deference in which one hand is placed below the chin. Twin-retainer imagery is apparent on a more intimate and delicate scale in the design of the hand-held beaded ceremonial fly whisk from Bamun, illustrated in plate 24, on which a pair of seated retainers are shown with their hands on their knees. At the Bamun palace, specially designated twins supervised coronations and guarded the king's burial ground. As the embodiment of abundance, twins, like the king, were associated with prosperity and fertility (Blier 1998, p. 189). Throughout the Grassfields, the birth of twins is announced to the king, who then adopts them; such children are believed to afford rulers supernatural power (ibid.).

III G. CHOKWE

Chokwe leaders from Angola historically also have commissioned elaborate and distinctive seats of office from professional sculptors (Kauenhoven-Janzen 1981, p. 69). Their preferred design was adapted from that of a European chair and enhanced with a sculptural program on the rungs, splats, and legs. Such works give expression to their owners' power and prestige and are conceived of as

thrones. They comment at once upon a chief's political position and rank as well as on his spiritual authority. Reinhild Kauenhoven-Janzen (ibid., p. 70) has observed that this concept is reflected in the iconography of the scenes depicted, which juxtapose sacred and profane imagery as complementary opposites.

While the program of each Chokwe throne is a unique combination of images, each draws upon a classic repertory of motifs. The overall visual effect evokes an ideal of social harmony and emphasizes the importance of a community's continuity being protected by its leadership (ibid., p. 72). The throne in plate 25 features a couple at the summit positioned at either side of the chairback. The male and female figures may depict a chief and his senior wife, or mahamba, spirits of lineage ancestors that provide protection and serve as intermediaries between the Creator and humankind. Lower down on the bottom rung of the proper left side is a miniature couple whose bodies are interlaced in an embrace that binds them together. Formally similar miniature figurines referred to as yikoyi are among the elements in a Chokwe diviner's basket that comment on a client's potential fertility.

III H. SONGYE AND HEMBA

In other central African polities, seats of leadership owned by chiefs and kings took the form of stools with figurative supports as seen in plates 26 and 27. These Songye and Hemba examples depict male and female couples as the caryatid elements that unify the circular seat and base, but in radically different arrangements. The attenuated Hemba design emphasizes a graphically balanced bilateral symmetry in contrast to the Songye work in which man and woman are positioned back to back in a dynamic arrangement that demands to be viewed in the round. While the Hemba male and female figures standing

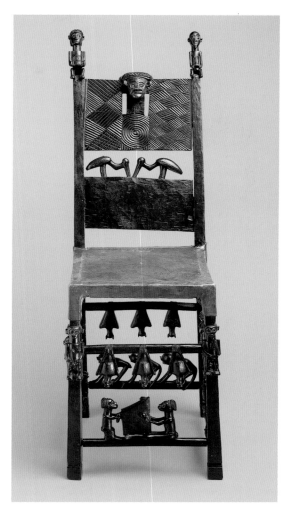

PLATE 25 Throne (*Ngunja*). Chokwe peoples, Angola, 19th–20th century. Wood and hide, H. 36$^{1}/_{2}$ in. (92.7 cm). Collection Drs. Daniel and Marian Malcolm. Detail (below) shows rungs on proper left side

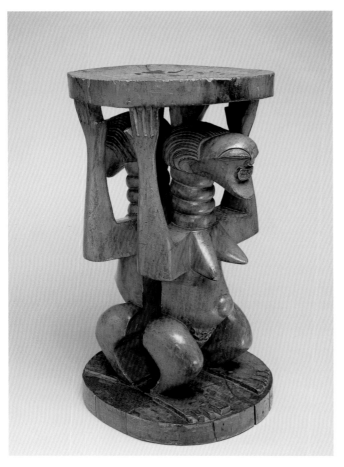

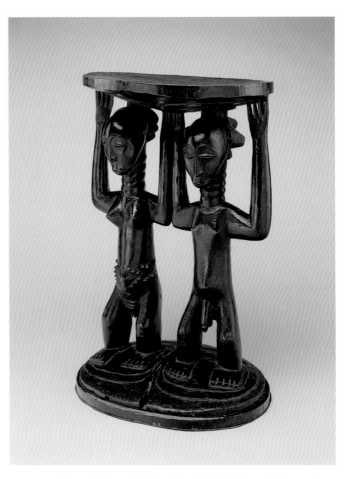

PLATE 26 Caryatid Seat of Office: Couple. Songye peoples, Democratic Republic of the Congo, 19th–20th century. Wood, H. 20¹/₂ in. (52.1 cm). Collection Laura and James J. Ross

PLATE 27 Caryatid Seat of Office: Couple. Hemba or Zela peoples, Democratic Republic of the Congo, 19th–20th century. Wood, H. 24 in. (61 cm). Collection Faith-dorian Wright

side by side each effortlessly support the seat together with their fingertips, the powerful physiognomies of the Songye couple, as well as their bent knees and raised, broad upper arms, suggest that they are bearing a colossal weight. In the Songye creation, male and female stand as independent figures separated by an empty vertical channel and are framed at top and bottom by the disks of the seat and base. Both figures are formally identical except for the carved projections of the female's breasts, which complement the rounded curves of her forehead, the superimposed rings of her columnar neck, and her

stomach, navel, and knees; these, in turn, are contrasted with the severe rectilinearity of both figures' arms and backs. It has been proposed that the number and gender of the figures depicted supporting such seats reflect the nature of the system of descent that conferred authority on its owner (Neyt 1977, pp. 489–91). Among the closely related Luba, comparable seats are conceived of as "spirit capitals," uniting the owner and his people with the ancestors and spirits that influence human experience. Such works are not functional artifacts but rather sacred receptacles in which the essence of kingship is enshrined.

IV Beginnings and Eternity

A diverse range of African sculptural tradi-
tions emphasize the symmetry of figural pair-
ings of males and females and represent them
as coequal partners related to either extreme
of the life-cycle spectrum. Such male and
female couples are created to address the
human desire to promote and support the
generation of new life as well as to assure
immortality in an ancestral realm. They may
be intended specifically to enhance human
fertility or, alternatively, for ancestral shrines
that elicit divine intervention. In some
instances complementary male and female
figurative pairs serve both to usher the
deceased into the ancestral realm and to fur-
ther regeneration and birth.

IV A. CHAMBA

Chamba figurative traditions from Nigeria's
Benue River valley, although minimally doc-
umented, have yielded striking visual state-
ments concerning human duality. The limited
contextual information concerning their
significance alludes to their placement in
sacred groves as part of royal ancestral shrines
(Stevens 1976, p. 33). In the work illustrated
in plate 28, a broad horizontal element spans
two vertical torsos and serves as their shared
lower body, which is supported by a single
pair of legs. The upper bodies of the truncated
figures lean slightly inward toward one
another and are virtually identical except for
variations in the designs of the sagittal crests
that crown their heads. While, in this exam-
ple, both torsos would appear to be androgy-
nous, in other, related Chamba works in this
sculptural genre, male and female genders are
explicitly articulated, with the female element
identified by breasts and a more pronounced
crest. Given this distinction, one may infer
that the contrasting coiffures depicted here

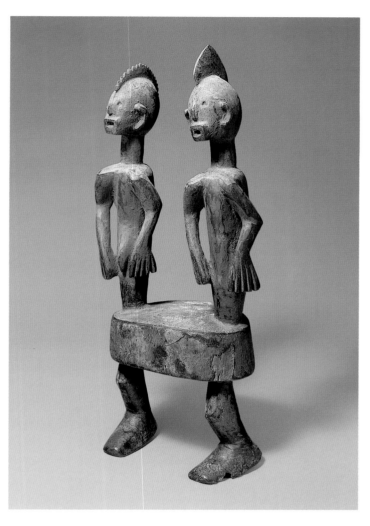

PLATE 28 Couple. Chamba peoples, Nigeria,
19th–20th century. Wood, with pigment, H. 21 in.
(53.3 cm). Collection Drs. Daniel and Marian Malcolm

identify the proper left torso as female and the
proper right one as male. Their abbreviated
facial features emphasize open, squared
mouths and ears that project outward. The
synergy of the upper bodies—framed by the
arms held at their sides and by the bent elbows
terminating in triangular hands—creates a sin-
gular vitality. On one level this design may
reflect basic Chamba assumptions concerning

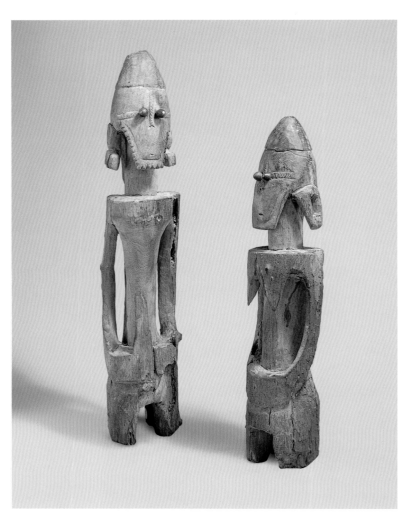

PLATE 29 Male and Female Figural Pair. Jukun peoples, Nigeria, 19th–20th century. Wood, H.: Male 27³/₄ in. (70.5 cm), Female 23¹/₄ in. (59.1 cm). Collection Drs. Daniel and Marian Malcolm

Among the neighboring Jukun, figurative couples may incarnate important kings and their spouses or Mam, a spirit concerned with human fertility. The couple seen in plate 29 represents Mam and his consort, who is distinguished formally from him only by her comparatively smaller scale and by the triangular breasts at the summit of her torso. The shared characteristics of their visages and schematic forms feature boldly projecting metallic eyes, severely squared jaws, conical headdresses with lateral flaps, and arms held at the sides of tubular torsos. Mam's presence is manifested in ceremonies through his possession of the devotees; these ceremonies generally occur either when the rains are due, or at harvesttime, or even as part of special appeals on behalf of barren women (Rubin 1969, pp. 82–84).

IV C. ZANDE

The severe reductive approach embodied by the couple in plate 30 belongs to a tradition allied with that of the Mangbetu. This pair has been variously attributed to a Zande or a Ngbandi artist from the Ubangi region of northwestern Democratic Republic of the Congo or Central African Republic. The pared-down structure of these figures is limited to a rounded head and a tubular trunk supported by prong-like legs. The arms, rendered in low relief, issue from right below the neck and extend down the length of the torso, the elbows slightly bent. Gender differences are barely distinguished. Among the few details are inscribed, linear thatches of hair covering the heads, small seed-bead eyes, and triangular noses. Zande sculptural couples have been characterized as ancestors (Felix 1987, p. 202). Ngbandi communities venerate ancestors in familial enclosures that, on rare occasions, have included figural works (Burssens 1958, p. 136). The Ngbaka, also in

human existence that combine male and female aspects, but it also comments upon the interdependence of the living and the ancestral aspects of human experience. According to the Chamba perspective on personhood, a child derives its bodily substance from its mother's blood and milk, while its spirit is implanted into its physical being through its father's seed (Fardon 1988, p. 153) — which, in turn, may allow for the reincarnation of one of the father's ancestors.

the same region, place abstract paired figures, similar in form, in ancestral shrines, and invoke them for protection from sickness, death, poor harvests, and miscarriages (Verswijver et al. 1995, pp. 390–91); these couples have been related to a mythical pair of founding ancestors responsible for the multiplication of the human race, Nabo and Seto, who were both siblings and spouses.

IV D. MALAGASY

Couples are the primary subject of the large-scale sculptural monuments created for Vezo burial sites in Madagascar (Mack in Phillips 1995, pp. 147–50). These include males and females depicted intimately intertwined as well as pairs of independent male and female figures. The rituals that accompanied their dedication facilitated the incorporation of the deceased into the ancestral community and assured the flow of vitality from the dead to the living. Throughout Madagascar, a north-east orientation is considered sacred in view of the association of that axis with the rising sun, propitious events, and the relationship it is believed to have with ancestors. As a result, tombs are often situated northeast of settlements. Those funerary sites that relate to Vezo communities on Madagascar's western coast are located in inaccessible forests and sandy clearings distant from villages. Sculptures were positioned at opposite corners of rectangular, box-like wood tomb structures exposed to the elements. Depending on the gender of the deceased, a male or female figure was placed in the position of greatest importance, in the northeastern corner; there, it faced its partner of the opposite sex in the southwestern corner. This spatial positioning references the relationship of an ideal human union (Mack 1986, pp. 88–89).

The couple seen in plate 31 was designed for this kind of setting and formal interaction. The figures are unique in their animation, in

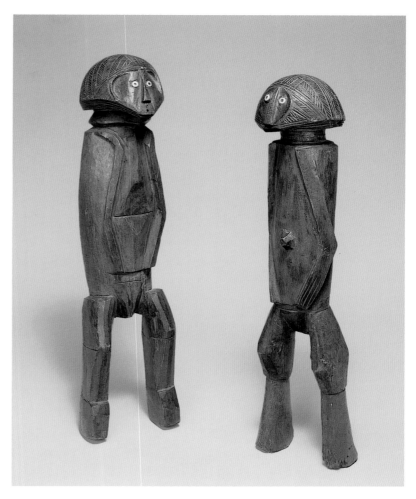

PLATE 30 Male and Female Figural Pair. Zande peoples, Democratic Republic of the Congo or Central African Republic, 19th–20th century. Wood, H.: Male 16 in. (40.6 cm), Female 15¼ in. (38.7 cm). Private collection

dramatic opposition to the static postures of most Vezo independent figural monuments. Their surfaces and forms exhibit evidence of extensive weathering and abrasion. The elements and forces of nature have played a significant role in shaping their appearance, and their attenuated limbs and blurred features contribute to their ethereal aesthetic. As a result, it is difficult to establish where the boundaries between the sculptor's hand end and the effects of erosion begin. However, their stances are deliberately dynamic, as is

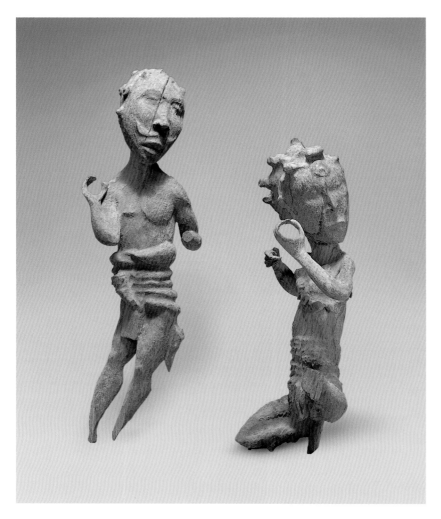

PLATE 31 Commemorative Couple. Vezo peoples, Madagascar, 19th–20th century. Wood, H.: Male 22^{7}/₁₆ in. (57 cm), Female 17^{11}/₁₆ in. (45 cm). Private collection

underscored by the attitudes of their turned heads, their raised arms, and the hands that once clasped items now missing. Their postures powerfully retain the suggestion that they are responding to each other's movements, making their connection eternally vital.

These "dancing" Vezo figures provide a powerful contrast to the stately couple illustrated in plate 32. Created by a Sakalava master to guard the entrance to a royal tomb at Tsianihy, the figures commemorate King Toera, who was killed by the French along with his supporters in 1897 (Sieber and Walker 1987, p. 144). While erosion has softened their features, they retain a solemn, commanding presence. The female, whose body is draped with a simple garment, gracefully balances a vessel on her head; her arms are at her sides, and her proper right hand is now empty. Her male counterpart, who once held a rifle and a lance, wears a skirt that falls just below the knees. These delicate contrasting details are subtle accents that distinguish the otherwise symmetrical depictions. Given

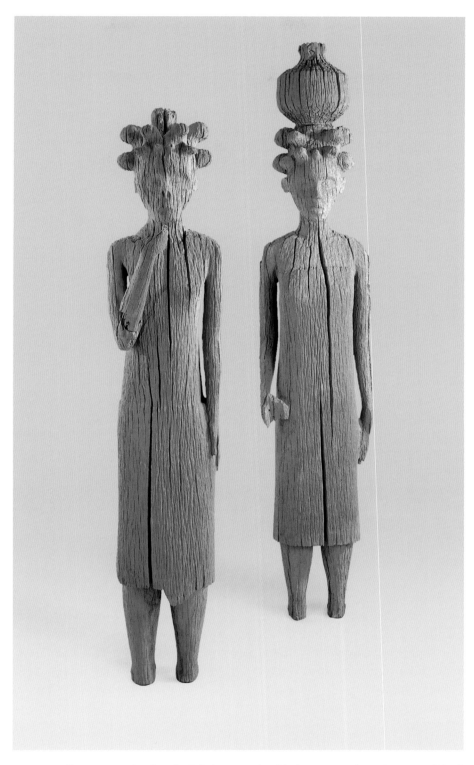

PLATE 32 Commemorative Couple. Sakalava peoples, Madagascar, 19th–20th century. Wood, H.: Male 70⁷/₈ in. (180 cm), Female 61⁷/₁₆ in. (156.1 cm). Private collection

that Sakalava commemorative sculptures are generally explicitly sexual in their nudity and depictions of passionate embraces, it is unusual that this couple is clothed and introspective in demeanor. While such works memorialize individuals, they are not conceived of as portraits but rather are reflections upon the concepts of birth and regeneration. John Mack (1986, p. 89) has emphasized that the living strive to maintain their own fertility by affording their deceased family members rebirth in the ancestral realm, noting (ibid., p. 51) that the fundamental pairing of death and regeneration with the life-giving forces attributed to royalty is celebrated in funerary rites that take place at the beginning of the first lunar month.

REFLECTIONS ON COUPLES IN AFRICAN ART

The decision to organize an exhibition focused on the concept of couples in African art derives from the remarkable visual record of an important corpus of sculpture that addresses this theme. Thus, the works of art themselves have served as a point of departure for delving into their respective meanings and for the consideration of the larger significance of an iconographic theme in African art that is also a universal one. It is evident that the subject has inspired African artists to create an especially rich body of works of exceptional aesthetic value.

By definition, a couple is at once two elements of a whole. In a world in flux, images of duality constitute commentaries on an ideally equilibrated state that may be achieved through the unification of opposing elements. While all of the pairs from the thirty distinct African cultural traditions considered here assume a figural form, they are never simply depictions of human subjects. Instead, in each of these diverse artistic traditions, idealized

human couples serve as a template that gives a mortal form to powerful forces conceived of as bridging several realms of experience and as having the potential to positively influence the lives of their patrons.

In the Western Sudan, couples may invoke primordial ancestors—as, for example, in the works created by Senufo and Dogon artists. Figural pairs may also honor twins that confer favor upon their families in Dogon, Bamana, and Senufo communities. The terracotta couples associated with the domestic compounds of Djenne's ancient civilization suggest invocations for protection, as do their related miniature, brass amuletic pendants. Throughout the Western Sudan, couples created by Senufo, Kulango, Lobi, Baga, and Bidjogo sculptors serve as mediums for divine forces, whose enlightened insights into the human condition allow them to intervene positively on behalf of their patrons.

A range of distinct sculptural genres complements Yoruba conceptions of a bipartite cosmos. Male and female Eshu wands represent a fundamental paired opposition that functions as a metaphor for the catalyst necessary to join the divine and terrestrial realms. The couples created as insignia of enlightened Osugbo elders similarly emphasize harnessing and overcoming differences to achieve a higher unity.

Throughout sub-Saharan Africa, figural pairs are part of the visual vocabulary of divinely sanctioned leadership. These range from delicate ivory miniature staff finials in the form of elegant male and female couples, which belong to Attie dignitaries, to works of art from the Benin court that portray pairs of attendants, such as Portuguese traders, as metaphors for the origins of the king's abundant wealth. The full array of royal artifacts created for a Luba sovereign's treasury often include female couples that personify the spirits of divine kingship. The ultimate emblem

of a leader's authority in many central African cultures is the seat of office, whose couple imagery alludes to its owner's source of authority as well as to associations with fertility. Chamba, Jukun, Zande, and Malagasy traditions feature couples that were made for shrines and that personify prayers for children and new life while also commemorating the dead as expressions of hope for an afterlife.

Represented here by inspired artistic creations, all of the couple genres considered served to enhance and fortify their owners' desires for well-being and status in society. It is significant that these divine pairings without exception articulate a vision of symmetry and gender equality. Despite the richly diverse and infinitely varied approaches to the human form, each distinct vision of a couple constitutes a calculated combination of repetitions and subtle, nuanced departures. While the individual components that comprise these pairs are almost mirror images of one another, invariably the deliberate introduction of slight formal variations define their identity as two separate elements of a unified whole. Although designed to reference immaterial forces, their human forms suggest at once the dual aspects of a single being and the ideal partnerships we all seek to achieve completeness or fulfillment.

Exhibition Checklist

The works in the exhibition are listed here according to the culture in which each was created. Unless specified otherwise, the dimensions are given as follows: height (or length) precedes width (precedes depth).

Djenne Civilization, Mali

PENDANT: COUPLE
15th century
Brass, 2 × 1¼ in. (5.1 × 3.2 cm)
Private collection

SEATED COUPLE (see plate 1)
12th–16th century
Terracotta, H. 10 in. (25.4 cm)
Collection Drs. Daniel and Marian Malcolm

SEATED COUPLE (see plate 2)
12th–16th century
Terracotta, H. 11⅛ in. (28.3 cm)
Collection Drs. Daniel and Marian Malcolm

PENDANT: COUPLE (see plate 3)
15th century
Brass, H. 2⁹⁄₁₆ in. (6.5 cm)
Collection Jeffrey B. Soref

EMBRACING COUPLE
12th–16th century
Terracotta, 17 × 6½ × 7½ in.
(43.2 × 16.5 × 19.1 cm)
Private collection

Dogon peoples, Mali

TOGUNA SUPPORT POST:
MALE AND FEMALE FIGURES
19th–20th century
Wood and metal, H. 75 in. (190.5 cm)
The Metropolitan Museum of Art, New York.
Gift of Lester Wunderman, 1979 (1979.541.5)

GRANARY DOOR AND LOCK (see plate 4)
19th–20th century
Wood, 23¼ × 17 in. (59.1 × 43.2 cm)
Clyman Collection

PRIMORDIAL COUPLE (see frontispiece)
16th–19th century
Wood and metal, H. 28¾ in. (73 cm)
The Metropolitan Museum of Art, New York.
Gift of Lester Wunderman, 1977 (1977.394.15)

Bamana peoples, Segou region, Mali

MALE AND FEMALE TWIN FIGURES
(*Flanitokele*) (see plate 5)
19th–20th century
Wood, H.: Male 21¾ in. (55.1 cm), Female 22¾ in.
(57.8 cm)
Collection Laura and James J. Ross

Senufo peoples, Côte d'Ivoire

DIVINER'S FIGURES: COUPLE (see plate 6)
19th–20th century
Wood, H.: Male 15 in. (38.1 cm), Female 15½ in.
(39.4 cm)
Collection Laura and James J. Ross

MASK: TWO FACES (*Kotopitya*) (see plate 7)
19th–20th century
Wood, H. 12⅝ in. (32 cm)
Collection Laura and James J. Ross

COUPLE
19th–20th century
Brass, H. 1¾ in. (4.4 cm)
Collection Brian and Diane Leyden

Kulango peoples, Côte d'Ivoire

COUPLE FIGURINES (see plate 8 for a–d)
17th–18th century
Brass
a. Couple: H. 1¹⁄₁₆ in. (2.7 cm)

b. Couple: H. 1¾ in. (4.5 cm)
c. Couple: H. 1¹⁄₁₆ in. (2.7 cm)
d. Couple: H. 1¼ in. (3.2 cm)
e. Equestrian Couple: H. 2½ in.
(6.4 cm)
Collection Brian and Diane Leyden

Lobi peoples, Burkina Faso

SEATED COUPLE
19th–20th century
Brass, H. 1⅝ in. (4.1 cm)
Collection Brian and Diane Leyden

FEMALE AND MALE SHRINE FIGURES
(*Bateba*) (see plate 9)
19th–20th century
Wood and fiber, H.: Female 20½ in. (52.1 cm),
Male 21½ in. (54.6 cm)
Private collection

Baga peoples, Guinée

D'MBA COUPLE (see plate 10)
19th–20th century
Wood, H.: Male 26⅜ in. (67 cm), Female 27³⁄₁₆ in.
(69 cm)
High Museum of Art, Atlanta. Fred and
Rita Richman Collection (2002.281.1-2)

Bidjogo peoples, Bissagos Islands, Guinée

SEATED MALE AND FEMALE FIGURAL PAIR
(see plate 11)
19th–20th century
Wood, H.: Male 14⅞ in. (37.8 cm), Female 15¾ in.
(40 cm)
Schorr Family Collection

Bidjogo or Bulom (?) peoples, Guinée-Bissau or Sierra Leone

MANKALA GAME BOARD WITH FIGURAL PAIR
(see plate 12)
19th–20th century
Wood, 6 × 3¼ × 3¾ in. (15.2 × 8.3 × 9.5 cm)
Brooklyn Museum of Art, New York
(22.239)

Baule peoples, Côte d'Ivoire

HEDDLE PULLEY: JANUS
19th–20th century
Wood, H. 11¼ in. (28.6 cm)
Private collection

HEDDLE PULLEY: FEMALE AND MALE HEADS
19th–20th century
Wood and beads, H. 19½ in. (49.5 cm)
Collection Brian and Diane Leyden

DIVINER'S DOUBLE FIGURE (see plate 18)
19th–20th century
Wood, H. 18⅛ in. (46.1 cm)
Collection Drs. Daniel and Marian Malcolm

Attie group, Lagoons peoples, Côte d'Ivoire

PAIR OF STAFF FINIALS: MALE AND FEMALE
SEATED FIGURES (see plate 17)
17th–18th century
Ivory, H.: Male 5⅞ in. (15 cm), Female 7¹⁄₁₆ in.
(18 cm)
Collection Laura and James J. Ross

Yoruba peoples, Nigeria

PAIR OF ESHU DANCE WANDS: MALE AND
FEMALE KNEELING FIGURES (see plate 13)
19th–20th century
Wood and beads, H.: Male 13¾ in. (34.9 cm),
Female 14 in. (35.6 cm)
Private collection

PAIR OF MALE AND FEMALE TWIN FIGURES
(*Ibedji*) (see plate 14)
19th–20th century
Wood and beads, H.: Male 11¾ in. (29.8 cm),
Female 11¼ in. (28.6 cm)
Private collection

EDAN OSUGBO (see plate 15)
19th–20th century
Brass, H. (each) 13½ in. (34.3 cm)
Collection Laura and James J. Ross

EDAN OSUGBO (see plate 16)
19th–20th century
Brass, H. (each) 13 in. (33 cm)
Collection Laura and James J. Ross

IFA DIVINATION BOWL: FIGURAL PAIR
19th–20th century
Wood, H. 10½ in. (26.7 cm)
Collection Drs. Nicole and John Dintenfass

Edo peoples, Kingdom of Benin, Nigeria

MACE HEAD: LEOPARD FLANKED BY
PORTUGUESE (see plate 19)
16th–17th century
Brass, H. 9½ in. (24.1 cm)
Collection Laura and James J. Ross

Chamba peoples, Nigeria

COUPLE (see plate 28)
19th–20th century
Wood, with pigment, H. 21 in. (53.3 cm)
Collection Drs. Daniel and Marian Malcolm

Wurkun peoples, Nigeria

FEMALE AND MALE FIGURAL PAIR
19th–20th century
Wood and organic matter, H.: Male 17½ in.
(44.5 cm), Female 16⅞ in. (42.9 cm)
Private collection

Jukun peoples, Nigeria

MALE AND FEMALE FIGURAL PAIR (see
plate 29)
19th–20th century
Wood, H.: Male 27¾ in. (70.5 cm), Female 23¼ in.
(59.1 cm)
Collection Drs. Daniel and Marian Malcolm

Bamileke peoples, Grassfields region, Bansoa chiefdom, Cameroon

THRONE: ROYAL COUPLE (see plate 23)
19th–20th century
Wood, glass beads, cloth, and cowrie shells,
H. 63 in. (160 cm)
Private collection

Bamun peoples, Grassfields region, Cameroon

CEREMONIAL FLY WHISK: PAIR OF ROYAL
ATTENDANTS (see plate 24)
19th–20th century
Wood, cowrie shells, horsetail, beads, and fiber,
H. 20 in. (50.8 cm)
Private collection

Chokwe peoples, Angola

THRONE (*Ngunja*) (see plate 25)
19th–20th century
Wood and hide, H. 36½ in. (92.7 cm)
Collection Drs. Daniel and Marian Malcolm

Kongo peoples, Bomba region, Democratic Republic of the Congo

WHISTLE: ENTWINED COUPLE
19th–20th century
Wood, H. 8⅜ in. (21.3 cm)
Collection Elliot and Amy Lawrence

Hemba or Zela peoples, Democratic Republic of the Congo

CARYATID SEAT OF OFFICE: COUPLE (see
plate 27)
19th–20th century
Wood, H. 24 in. (61 cm)
Collection Faith-dorian Wright

Luba peoples, Democratic Republic of the Congo

HEADREST: FEMALE COUPLE (see plate 20)
19th–20th century
Wood, H. 7¼ in. (18.4 cm)
Collection Drs. Daniel and Marian Malcolm

HEADREST: FEMALE COUPLE
19th–20th century
Wood, H. 7¼ in. (18.4 cm)
Collection Milton and Frieda Rosenthal

Mangbetu peoples, Democratic Republic of the Congo

MALE AND FEMALE FIGURAL PAIR (see cover and plate 21)
19th–20th century
Wood, H.: Male 24½ in. (62 cm), Female 24 in. (61 cm)
Private collection

DOUBLE VESSEL (see plate 22)
Early 20th century
Terracotta, H. 8⅝ in. (22 cm)
American Museum of Natural History, New York (413 cat 90.1/4693A)

Zande peoples, Democratic Republic of the Congo or Central African Republic

MALE AND FEMALE FIGURAL PAIR (see plate 30)
19th–20th century
Wood, H.: Male 16 in. (40.6 cm), Female 15¼ in. (38.7 cm)
Private collection

Songye peoples, Democratic Republic of the Congo

CARYATID SEAT OF OFFICE: COUPLE (see plate 26)
19th–20th century

Wood, H. 20½ in. (52.1 cm)
Collection Laura and James J. Ross

JANUS FIGURE
19th–20th century
Wood, pigments, cloth, hide, metal, beads, and organic matter, H. 30 in. (76.2 cm)
Collection Carol and Jerome Kenney

Sakalava peoples, Madagascar

COMMEMORATIVE COUPLE (see plate 32)
19th–20th century
Wood, H.: Male 70⅞ in. (180 cm), Female 61⁷⁄₁₆ in. (156.1 cm)
Private collection

Vezo peoples, Madagascar

COMMEMORATIVE COUPLE (see plate 31)
19th–20th century
Wood, H.: Male 22⁷⁄₁₆ in. (57 cm), Female 17¹¹⁄₁₆ in. (45 cm)
Private collection

Jiji peoples, Tanzania

FEMALE AND MALE FIGURAL PAIR
19th–20th century
Wood, metal, and beads, H.: Female 19½ in. (49.5 cm), Male 27 in. (68.6 cm)
Collection Robert and Nancy Nooter

Works Cited

Abiodun, Rowland, Henry John Drewal, and John Pemberton III

1991 *Yoruba: Art and Aesthetics in Nigeria.* Edited by Lorenz Homberger. Exhib. cat. Zürich: Museum Rietberg; New York: Center for African Art.

Barbier, Jean Paul, ed.

1993 *Art of Côte d'Ivoire: From the Collections of the Barbier-Mueller Museum.* 2 vols. Contributions by Jean-Noël Loucou, Anita Glaze, Gilbert Bochet, Timothy F. Garrard, Jean Paul Barbier, René Bravmann, Marie-Noël Verger-Fèvre, Pierre Harter, Elze Bruyninx, Ariane Deluz, Alain-Michel Boyer, and Monica Blackmun Visonà. Geneva: Musée Barbier-Mueller.

Blier, Suzanne Preston

1998 *The Royal Arts of Africa: The Majesty of Form.* New York: Harry N. Abrams.

Brincard, Marie-Thérèse, ed.

1982 *The Art of Metal in Africa.* Translations and additional research by Evelyn Fischel. Exhib. cat. New York: African-American Institute.

Burssens, Herman

1958 *Les Peuplades de l'entre Congo-Ubangi: Ngbandi, Ngbaka, Mbandja, Ngombe et Gens d'Eau.* Annales du Musée Royal du Congo Belge. Sciences de l'Homme; Monographies Ethno-graphiques, no. 4. London: International African Institute.

Cole, Herbert M.

1989 *Icons: Ideals and Power in the Art of Africa.* Exhib. cat. Washington, D.C.: National Museum of African Art; Smithsonian Institution Press.

DeMott, Barbara

1982 *Dogon Masks: A Structural Study of Form and Meaning.* Studies in the Fine Arts; Iconography, no. 4. Ann Arbor: UMI Research Press.

Drewal, John Henry, John Pemberton III, and Rowland Abiodun

1989 *Yoruba: Nine Centuries of African Art and Thought.* Edited by Allen Wardwell. Exhib. cat. New York: Center for African Art.

Ezra, Kate

1986 *A Human Ideal in African Art: Bamana Figurative Sculpture.* Exhib. cat. Washington D.C.: National Museum of African Art; Smithsonian Institution Press.

1988 *Art of the Dogon: Selections from the Lester Wunderman Collection.* Exhib. cat. New York: The Metropolitan Museum of Art.

Fagg, William

1982 *Yoruba, Sculpture of West Africa.* Descriptive catalogue by John Pemberton III; edited by Bryce Holcombe. New York: Knopf.

Fardon, Richard

1988 *Raiders and Refugees: Trends in Chamba Political Development, 1750 to 1950.* Washington, D.C.: Smithsonian Institution Press.

Felix, Marc Leo

1987 *100 Peoples of Zaire and Their Sculpture: The Handbook.* Brussels and San Francisco: Zaire Basin Art History Research Foundation.

Garlake, Peter

2002 *Early Art and Architecture of Africa.* Oxford: Oxford University Press.

Geary, Christraud

1983 *Things of the Palace: A Catalogue of the Bamum Palace Museum in Foumban (Cameroon).* Studien zur Kulturkunde, vol. 60. Wiesbaden: Franz Steiner Verlag GMBH.

Glaze, Anita J.

1981 *Art and Death in a Senufo Village.* Bloomington: Indiana University Press.

Griaule, Marcel

1947 "Nouvelles Recherches sur la notion de personne chez les Dogons (Soudan français)."

Journal de psychologie normale et pathologique 40, no. 4, pp. 425–31.

Imperato, Pascal James
1975 "Bamana and Maninka Twin Figures." *African Arts* 8, no. 4, pp. 52–60, 83–84.

Itzikovitz, Max
1975 "À propos d'un bronze abron." *Arts d'Afrique noire* 16 (winter), pp. 8–11.

Kauenhoven-Janzen, Reinhild
1981 "Chokwe Thrones." *African Arts* 14, no. 3, pp. 69–74, 92.

Lamp, Frederick
1996 *Art of the Baga: A Drama of Cultural Reinvention.* Forewords by Simon Ottenberg and Djibril Tamsir Niane; contributions by Sekou Beka Bangoura et al. Exhib. cat. New York: Museum for African Art; Munich: Prestel.

Mack, John
1986 *Madagascar: Island of the Ancestors.* London: British Museum Publications.

Malaquais, Dominique
1999 "A Robe Fit for a Chief." *Record of the Art Museum, Princeton University* 58, no. 1–2, pp. 16–37.

Mark, Peter
1987 "Two Carved Columns from Grand Bassam." *African Arts* 20, no. 2, pp. 56–59.

McIntosh, Roderick J., and Susan Keech McIntosh
1975 "Terracotta Statuettes from Mali." *African Arts* 12, no. 2, pp. 51–53, 91.
1981 "The Inland Niger Delta before the Empire of Mali: Evidence from Jenne-Jeno." *Journal of African History* 22, no. 1, pp. 1–22.

Meyer, Piet
1981a *Kunst und Religion der Lobi.* Exhib. cat. Zürich: Museum Rietberg.
1981b "Art et religion des Lobis." *Arts d'Afrique noire* 39 (autumn), pp. 16–22.
1991 "Divination among the Lobi of Burkina Faso." In *African Divination Systems: Ways of Knowing,* edited by Philip M. Peek, pp. 91–100. Bloomington: Indiana University Press.

Neyt, François
1977 *La Grande Statuaire hemba du Zaïre.* Publications d'histoire de l'art et d'archéologie de l'Université Catholique de Louvain, no. 12. Louvain-la-Neuve: Institut Supérieur d'Archéologie et d'Histoire de l'Art.

Northern, Tamara
1984 *The Art of Cameroon.* Exhib. cat. Washington, D.C.: National Museum of Natural History; Smithsonian Institution Traveling Exhibition Service.

Perrois, Louis, and Jean-Paul Notué
1997 *Rois et sculpteurs de l'Ouest Cameroun: La panthère et la mygale.* Paris: Karthala and ORSTOM.

Phillips, Tom, ed.
1995 *Africa: The Art of a Continent.* Exhib. cat. London: Royal Academy of Arts; Munich and New York: Prestel.

Plato
1937 *The Dialogues of Plato.* Translated by Benjamin Jowett. 2 vols. New York: Random House.

Ravenhill, Philip L.
1980 *Baule Statuary Art: Meaning and Modernization.* In Working Papers in the Traditional Arts, 5–6. Philadelphia: Institute for the Study of Human Issues.

Roberts, Mary Nooter, and Allen F. Roberts, eds.
1996 *Memory: Luba Art and the Making of History.* Contributions by S. Terry Childs, Pierre de Maret, and William J. Dewey. Exhib. cat. New York: Museum for African Art; Munich: Prestel.

Rubin, Arnold Gary
1969 "The Arts of the Jukun-Speaking Peoples of Northern Nigeria." Ph.D. diss., Indiana University, Bloomington.

Schildkrout, Enid, and Curtis A. Keim
1990 *African Reflections: Art from Northeastern Zaire.* Contributions by Didier Demolin, John Mack, Thomas Ross Miller, and Jan Vansina. Exhib. cat. New York: American Museum of Natural History; Seattle: University of Washington Press.

Sieber, Roy, and Arnold Rubin

1968 *Sculpture of Black Africa: The Paul Tishman Collection.* Exhib. cat. Los Angeles: Los Angeles County Museum of Art.

Sieber, Roy, and Roslyn Adele Walker

1987 *African Art in the Cycle of Life.* Exhib. cat. Washington, D.C.: National Museum of African Art; Smithsonian Institution Press.

Skougstad, Norman

1978 *Traditional Sculpture from Upper Volta: An Exhibition of Objects from New York Museums and Private Collections.* Exhib. cat. New York: African-American Institute.

Stevens, Phillips, Jr.

1976 "The Danubi Ancestral Shrine." *African Arts* 10, no. 1, pp. 30–37, 98–99.

Verswijver, Gustaaf, et al., eds.

1995 *Treasures from the Africa-Museum, Tervuren.* Exhib. cat. Tervuren, Belgium: Royal Museum for Central Africa.

Visonà, Monica Blackmun

1990 "Portraiture among the Lagoon Peoples of Côte d'Ivoire." *African Arts* 23, no. 4, pp. 54–61, 94–95.

Visonà, Monica Blackmun, et al.

2001 *A History of Art in Africa.* Preface by Rowland Abiodun; introduction by Suzanne Preston Blier. New York: Harry N. Abrams.

Vogel, Susan M.

1981 Editor. *For Spirits and Kings: African Art from the Paul and Ruth Tishman Collection.* Translations and additional research by Kate Ezra. Exhib. cat. New York: The Metropolitan Museum of Art.

1997 *Baule: African Art, Western Eyes.* Exhib. cat. New Haven: Yale University Art Gallery; Yale University Press, in association with the Museum for African Art.

Wingert, Paul S.

1962 *Primitive Art: Its Traditions and Styles.* New York: Oxford University Press.

Zahan, Dominique

1974 *The Bambara.* Iconography of Religions, sec. 7, Africa, fasc. 2. Leiden: E. J. Brill.